Man with a Camera

Shooting and Editing
Newspaper Picture Pages

Peter W. Morris

Man with a Camera
Shooting and Editing Newspaper Picture Pages

Photo by Christa Kelley

Peter W. Morris

Dedication

This book is dedicated to Ken Ketchie, the undisputed "leader of the pack" of journalists and publishers in northwestern North Carolina's High Country. While I'd had a string of newspaper photo positions to my credit when he hired me in 1987, it wasn't until I signed-on to his **Mountain Times** that I finally had an opportunity to produce a "picture-page-a-week" which would showcase my abilities with a camera. Here's to small weeklies! Thanks Ken!

I would also like to dedicate this book to my children and grandchildren, Jonathan, Christa, Taylor, Madelyn and Caleb, who may enjoy these images many years from now.

Special thanks to Jean Rice, whose assistance proved invaluable in the production of this book.

Foreword

Most people would think that a photojournalist's ultimate desire would be to work on a major newspaper such as the **New York Times** or a magazine like **Time** or one of the international wire services, the Associated Press or United Press International.

While admittedly being a "shooter" on one of these news outlets holds great prestige (it's these photojournalists' who win the biggest, most prestigious prizes, including Pulitzers) these photographers rarely see their work displayed in more than a few pictures. Large papers simply don't have the room for full-page displays, what with multitudes of news stories, features, columns and, of course, advertisements.

It is on the smaller publications where a photographer may shine through picture pages, especially if they are allowed to write, shoot, edit and lay out their own work.

While I have worked for some very large dailies, including those in Raleigh, North Carolina, the Miami-Ft. Lauderdale, Florida area and in Virginia, it was not until moving to the Appalachian Mountains and working for the **Mountain Times** that I found professional fulfillment.

It is with greatest pleasure when in working for this publication that I heard the same phrase form owner Ken Ketchie, week-after-week: "Peter, go out and find something worthy of a picture page."

What was the whipped cream on top of this cake was that Boone, North Carolina was a hub unlike most others in the

United States. We had the tallest mountains on the East Coast, snow and Nordic skiing, mountain climbing and rappelling, camping, Christmas tree farming and the harvesting of burley tobacco, fairs and festivals filling the months from May thru November, three professional theatres and as many colleges and universities.

Enough said! A photojournalist's paradise!

The picture pages that follow are but a small sampling of the photo-shoots this photographer has produced locally, although latter examples are from publications other than the **Mountain Times**.

Why this book? It is offered both for its substance—as in a text filled with ideas for photojournalists to undertake themselves—and as a study in how to edit and lay out pages with flair. Impact is what it's all about!

Said another way for shooters, use this rather unique book for inspiration...and enjoy the assignments!

Peter W. Morris

The Picture Page

There are picture pages and, then, there are picture pages. While this book contains many pages I would consider good (and some better than good), I regretfully recall when I did one of my first layouts on a small daily newspaper.

The page was on a couple who made whirligigs, those wooden wind-toys in which action figures—a farmer milking a cow, a woman churning butter, a kid flying a kite—performed their duties every time a hearty gust of wind would pass.

The regrettable aspect? I must have put 20-images on the page, way to many, very cluttered, horribly busy! This was a case when less would definitely have overshadowed more.

The best and most powerful picture pages allow for one image to dominate and several lesser one tell the story. One of the following pages used only three photos, yet it told the whole story...with a bit of help from a short box of copy.

Which brings up adding text to a picture page. If you are given the leeway of shooting, editing, writing and laying-out your own images, learn to add the text of the story yourself. You don't need a masters in journalism to write a short story of several paragraphs. If you choose to let someone else do the copy, then you'll be at the mercy of some editor...a bad idea. Editors are generally word-people and not photojournalists on the side.

Follows are a few suggestions for producing a picture page worth viewing.

- Plan your page in your mind while shooting the subject, picturing where each image might be placed in your layout.
- Look for one photograph which will speak for all the others on the page…a photo which will instantly draw attention.
- Ask yourself, "How can I make this picture stand out? Should I shoot slow so that the image has a bit of blur to show movement? Should I shoot the picture from a unique angle, high or low?
- Perhaps the image should be silhouetted, or the subject be shot in a sequence of photos.
- Don't go crazy with using to many pictures, limit your page to probably no more than six shots
- Consider how the page will look; should you use borders--only black borders--on your page or framing your photos in some other way.
- Consider placing your headline within a picture (the primary image) and don't forget the option of a small picture placed within a larger one.
- When you compose your copy, don't let it overcome your images, which could result in a page of copy highlighted by tiny pictures. Make the copy which accompanies your images short and to the point and consider boxing it to help set it off.

Perhaps you are at a loss for subject matter for your picture page. Don't wait for an editor to assign you one! Picture page subjects are *everywhere*, as

evidenced by selections in this book. Some I've personally shot in the past are not shown in this book such as:

- I followed a husband and wife through childbirth, starting with Lamaze classes and ending in the hospital delivery room. (Won second in the NC Press Association.)
- There was the ride-a-long with a state trooper doing "a day in the life of" a lawman.
- Fourth of July fireworks, with a child's wonderfully expressive face superimposed onto images of exploding fireworks...which were shot by time-exposure on a tripod.
- Spending a long night in a hospital emergency room where I caught the mayhem of unexpected trauma and harried doctors and nurses.
- A feature piece saw me following a surgeon on his daily rounds, which included him asking if I'd ever seen the human heart beating. He pulled a stepstool beside the operating table and jokingly warned me, "Just don't drop that Nikon into his chest."
- Several operations have come before my Nikons...cleft palette surgery, even circumcision.

Day-in-the-life picture pages might include the janitor at a school, an ambulance crew, construction workers, language teachers, football locker-room antics, workers at the Humane Society, yard maintenance workers...the photo ops are literally everywhere.

It is perhaps worth noting that almost all of the photo pages presented herein were self-assigned.

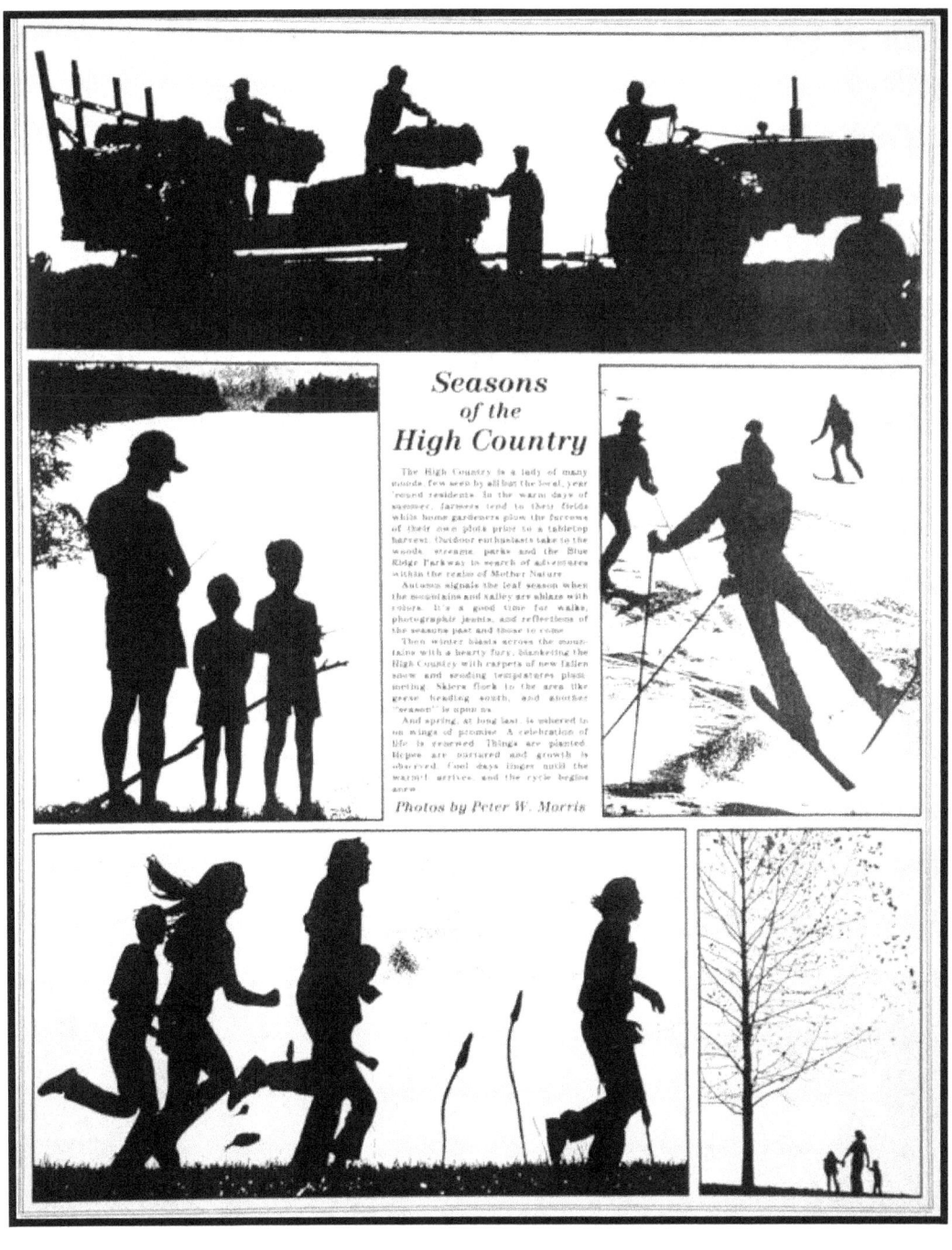

Silhouettes can make for stark and dramatic picture pages. I use them often for artistic effect.

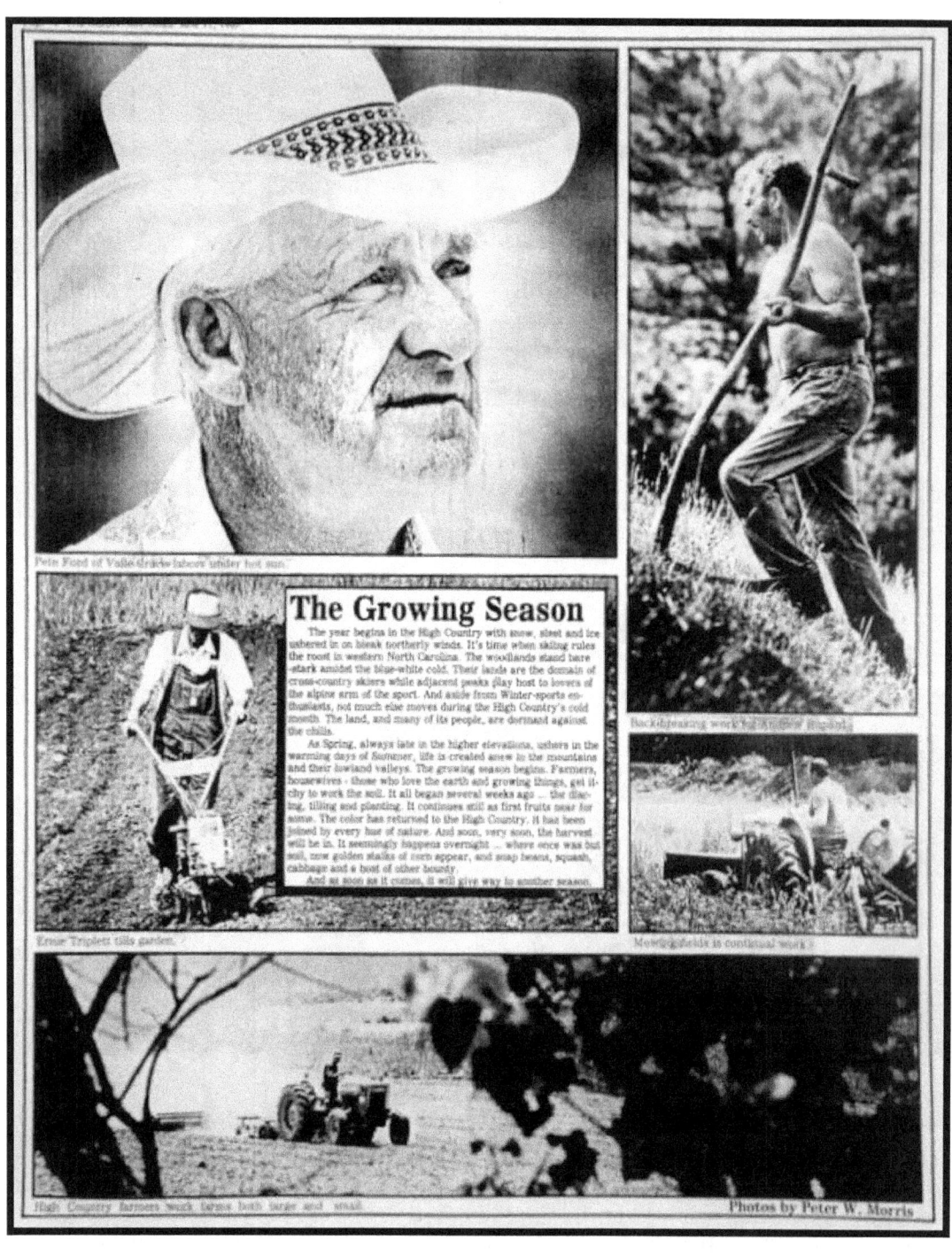

The Spring planting season is ripe with photo opportunities.

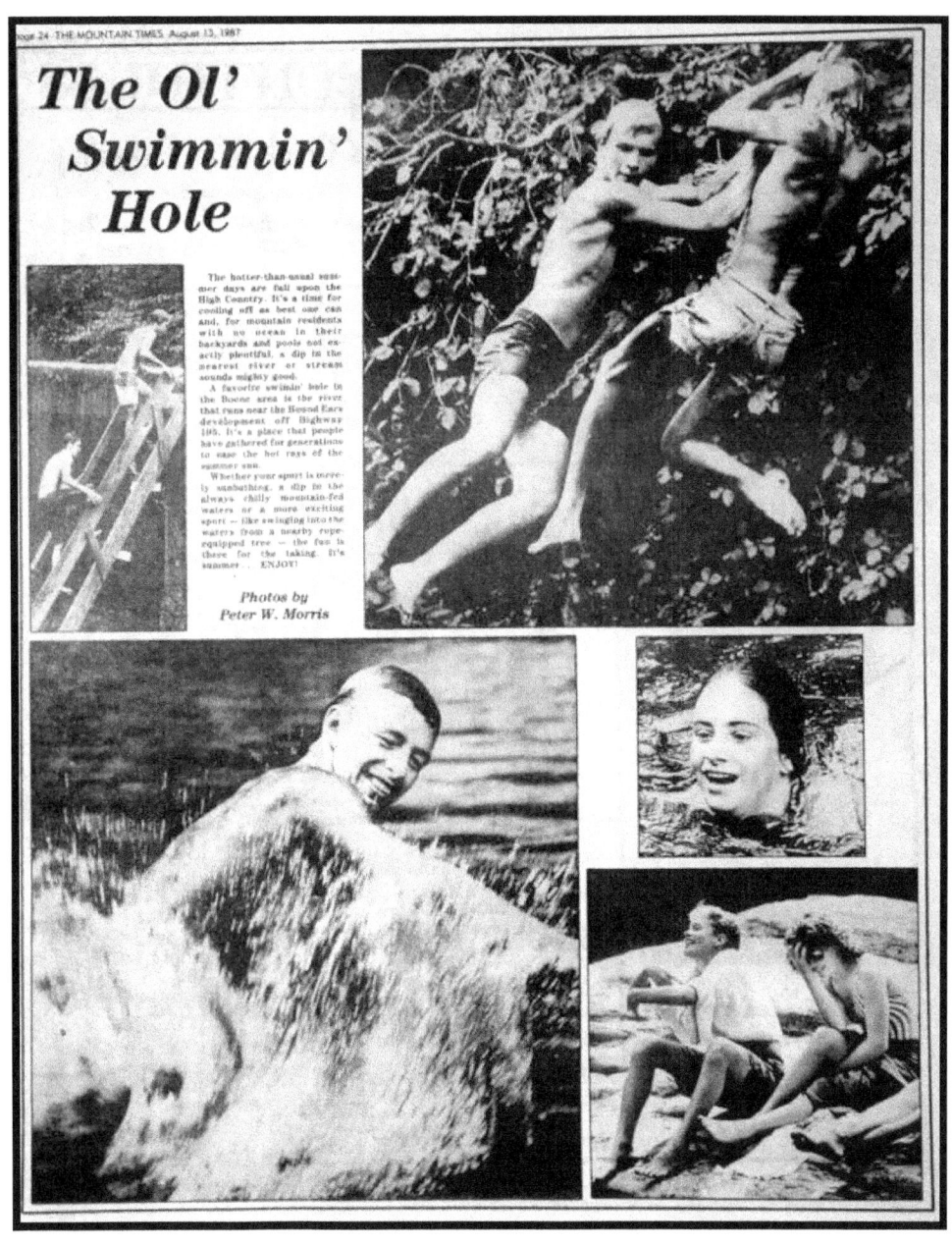

Who can resist the call of cool mountain streams on a warm supper day? Note how the action in these shots improves the telling of the story.

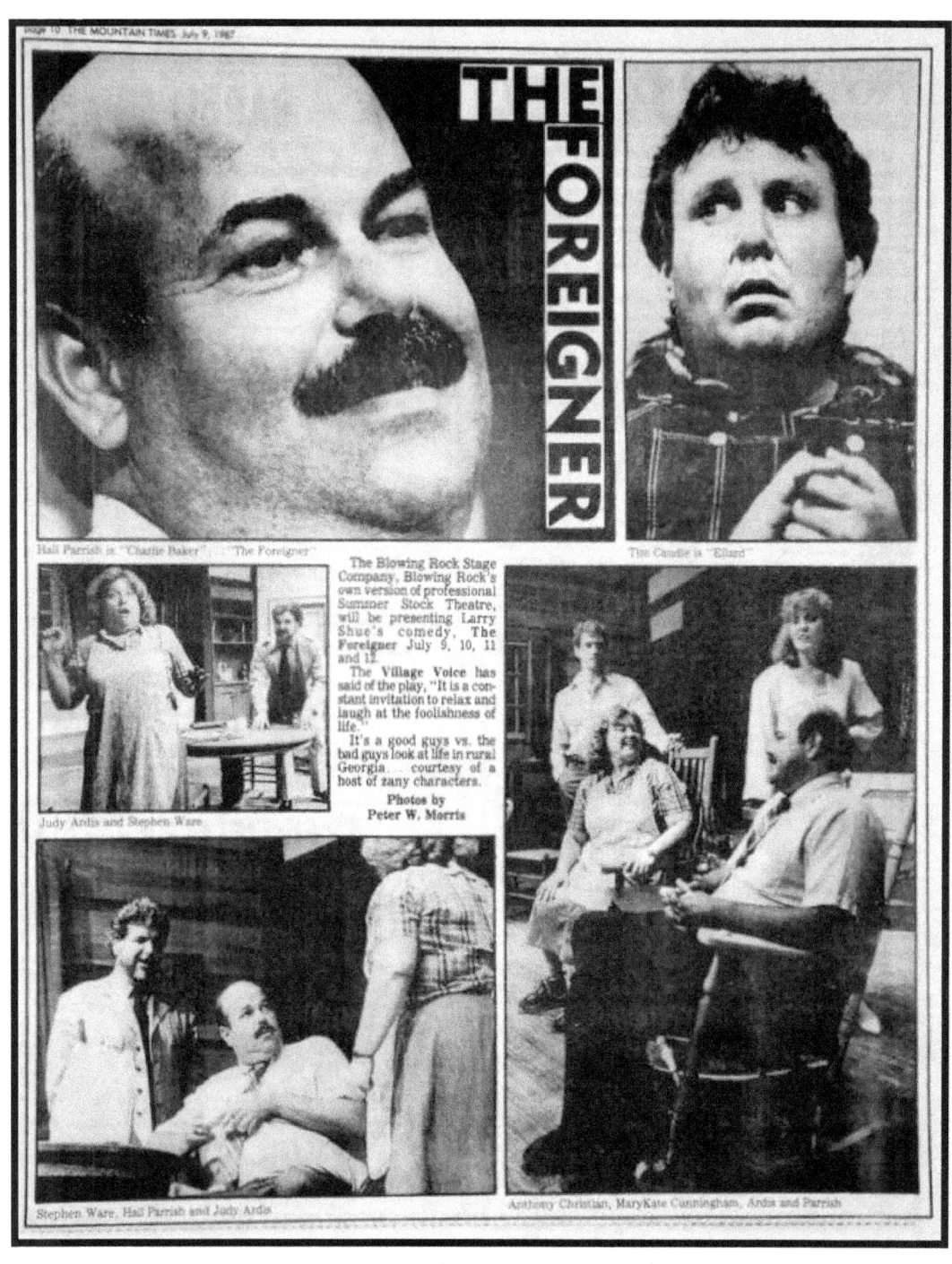

Stage productions are a favorite subject matter. The best pictures come when you photograph a final dress rehearsal.

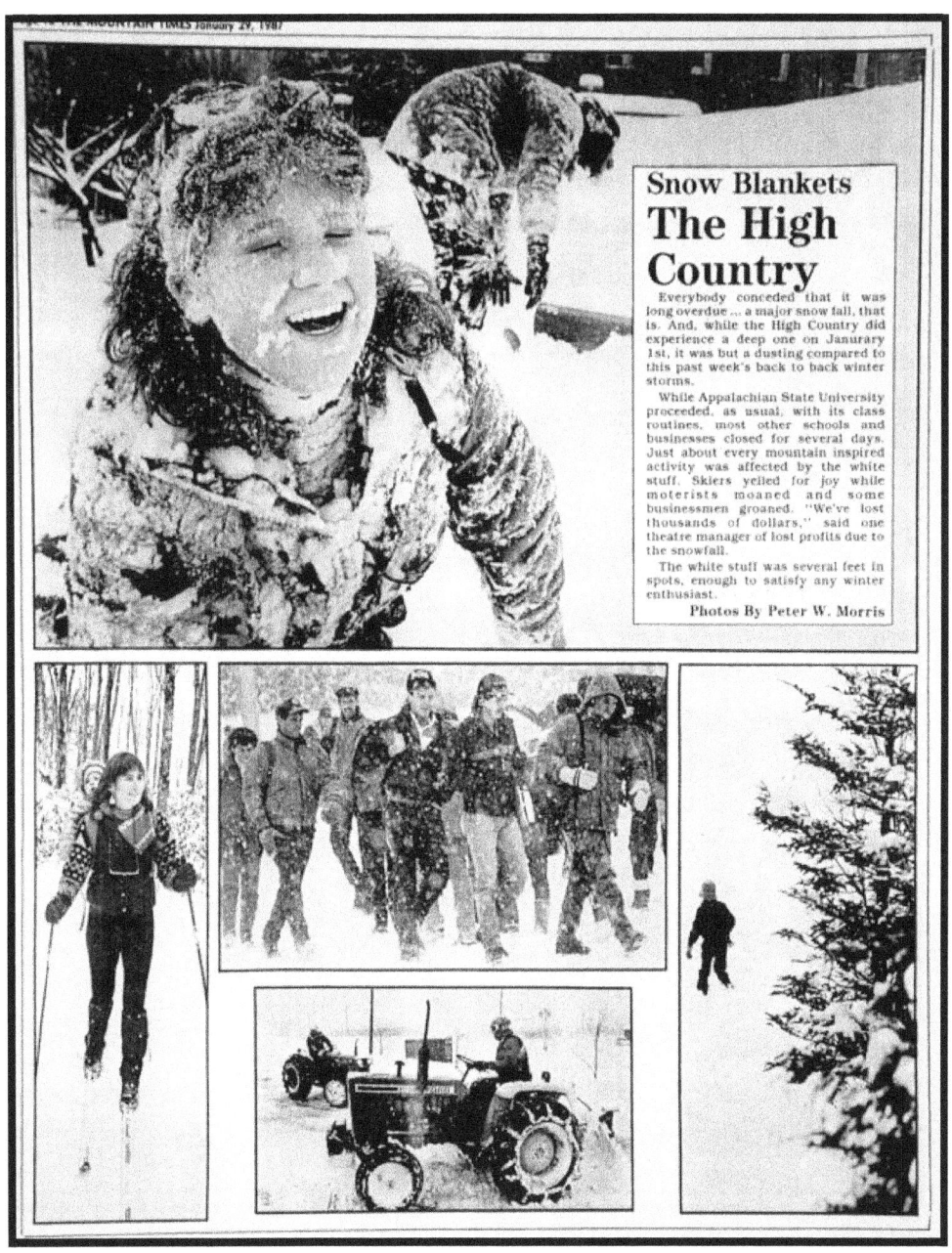

What better photo op than snow in the mountains, here in Boone, North Carolina. The student population at Appalachian State University provided for the subjects.

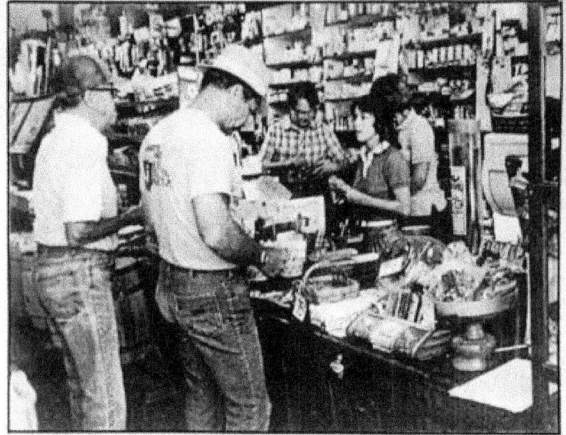

Country stores, the old fashioned kind, are located on back roads across the United States and in just about every country on Earth.

This page was produced for a newspaper advertiser.

A page more copy than pictures, but it still works.

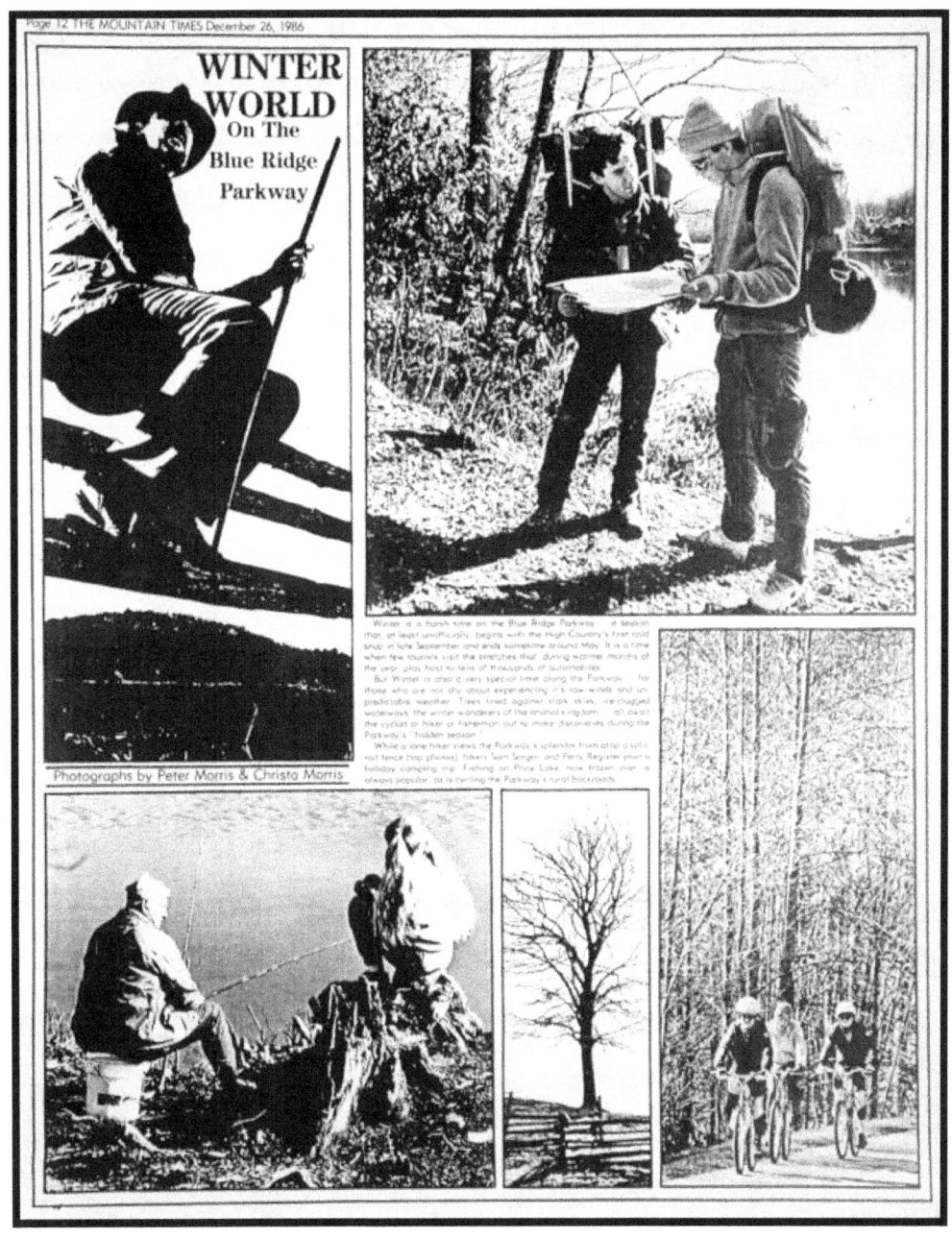

Sometimes it helps to have the photographer in the picture.
My young daughter took picture upper left.

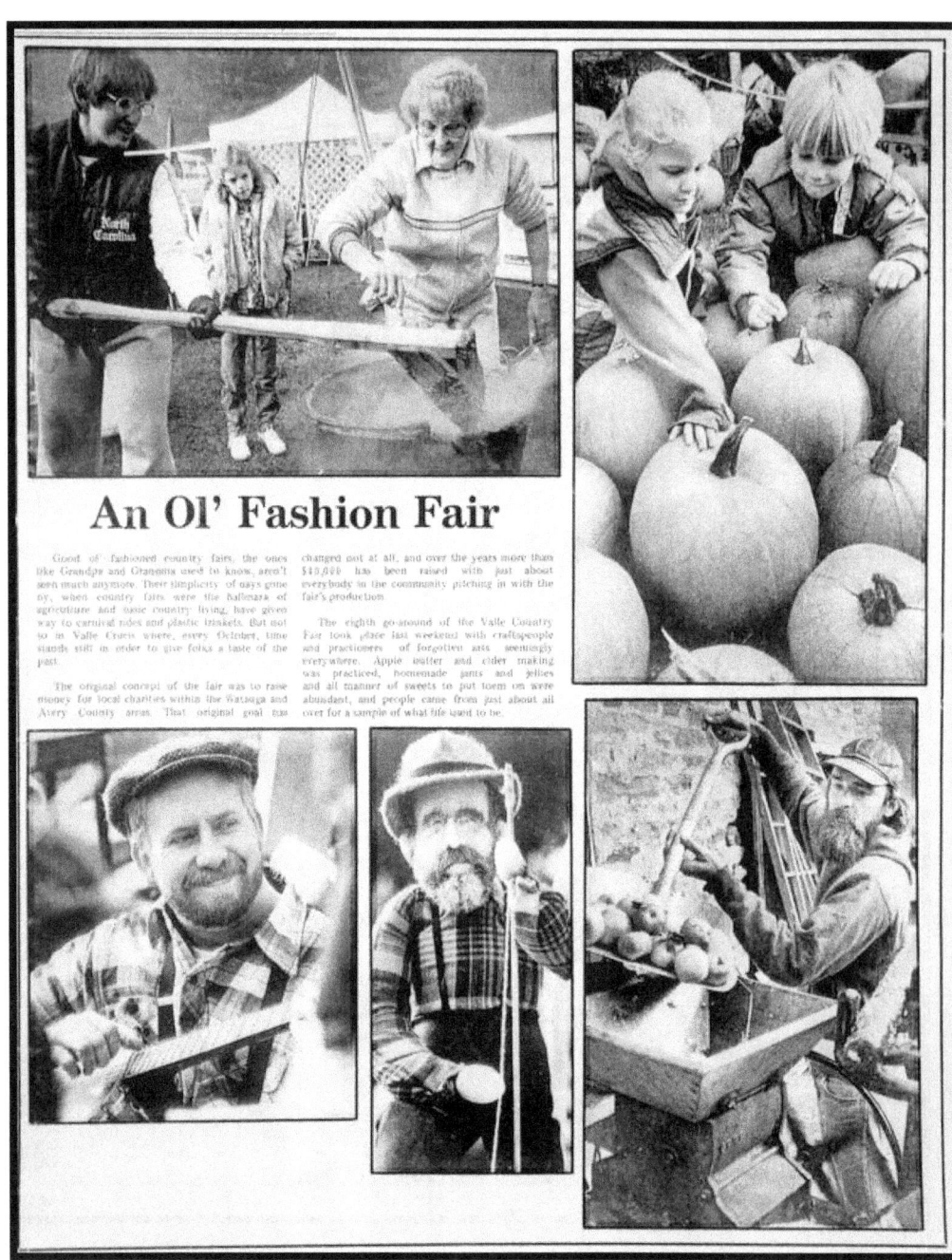

The October Valle Crucis fair has it all, molasses making, pumpkins aplenty, fresh brewed apple cider (worms and all) and artisans and musicians everywhere.

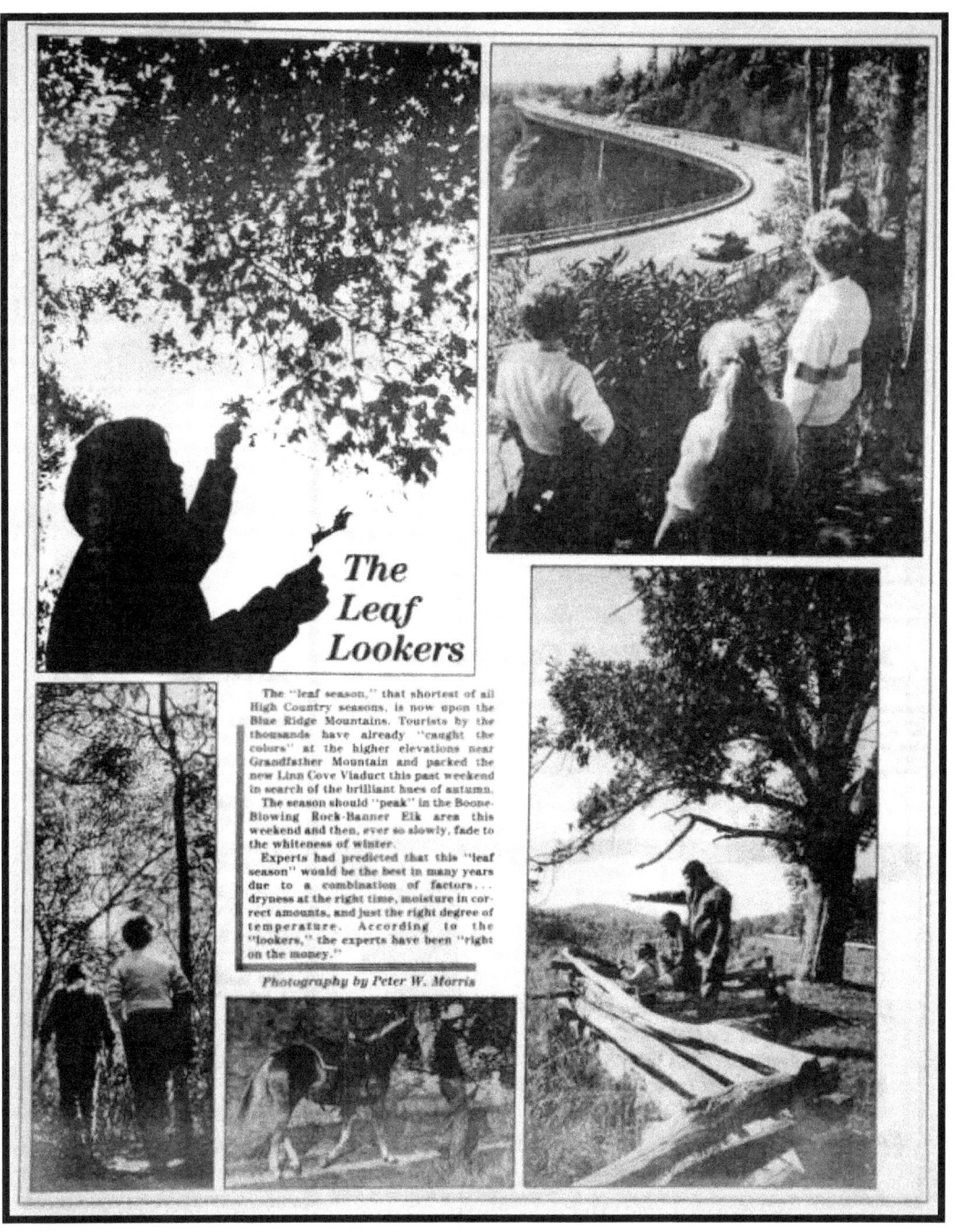

When not enough photo subjects are available, you add your children or friends to the scene, as with my son, upper left. The starkness of black on white adds drama.

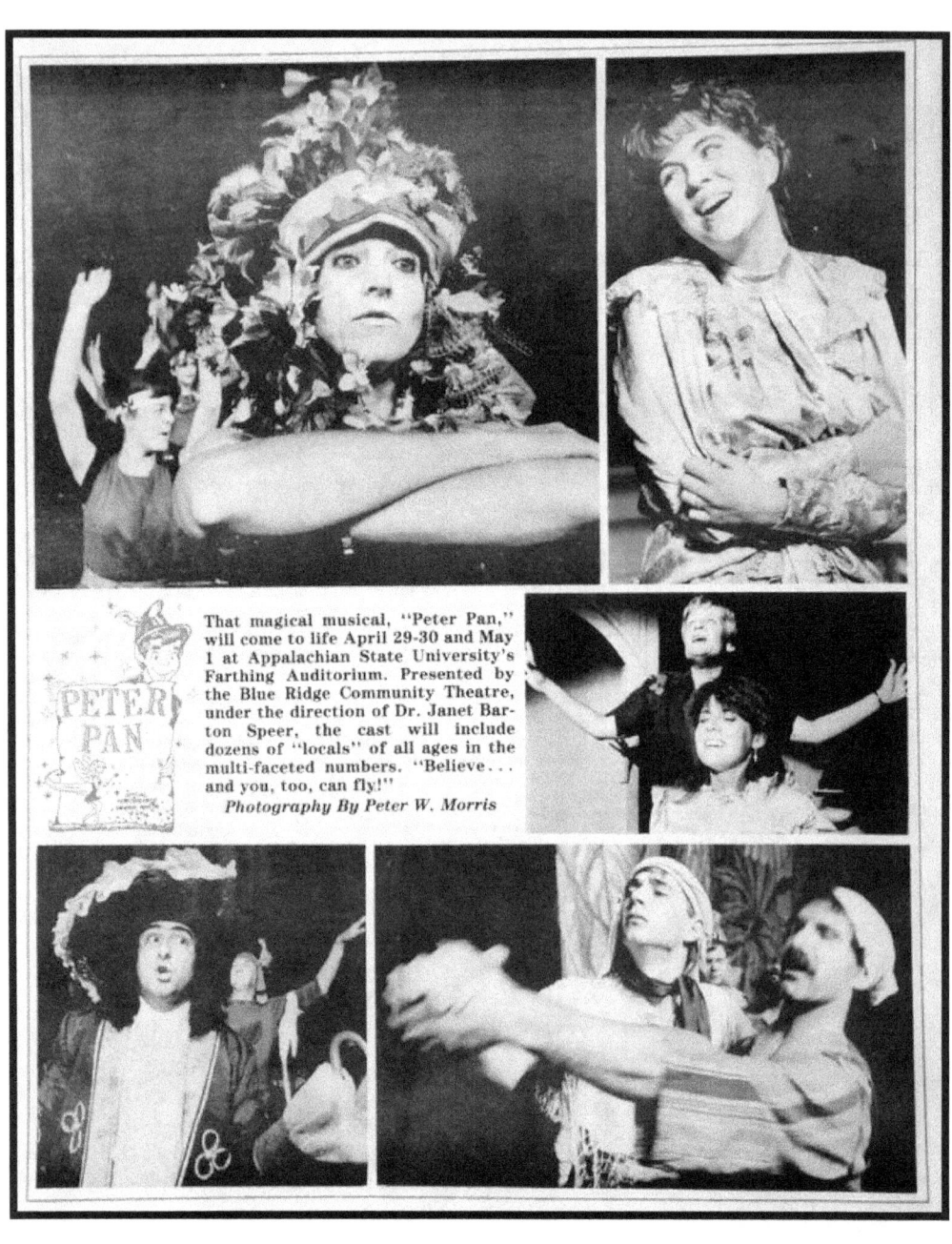

Stage plays always make for great shoots, with the actor's wardrobe and action sequences making for unequaled images.

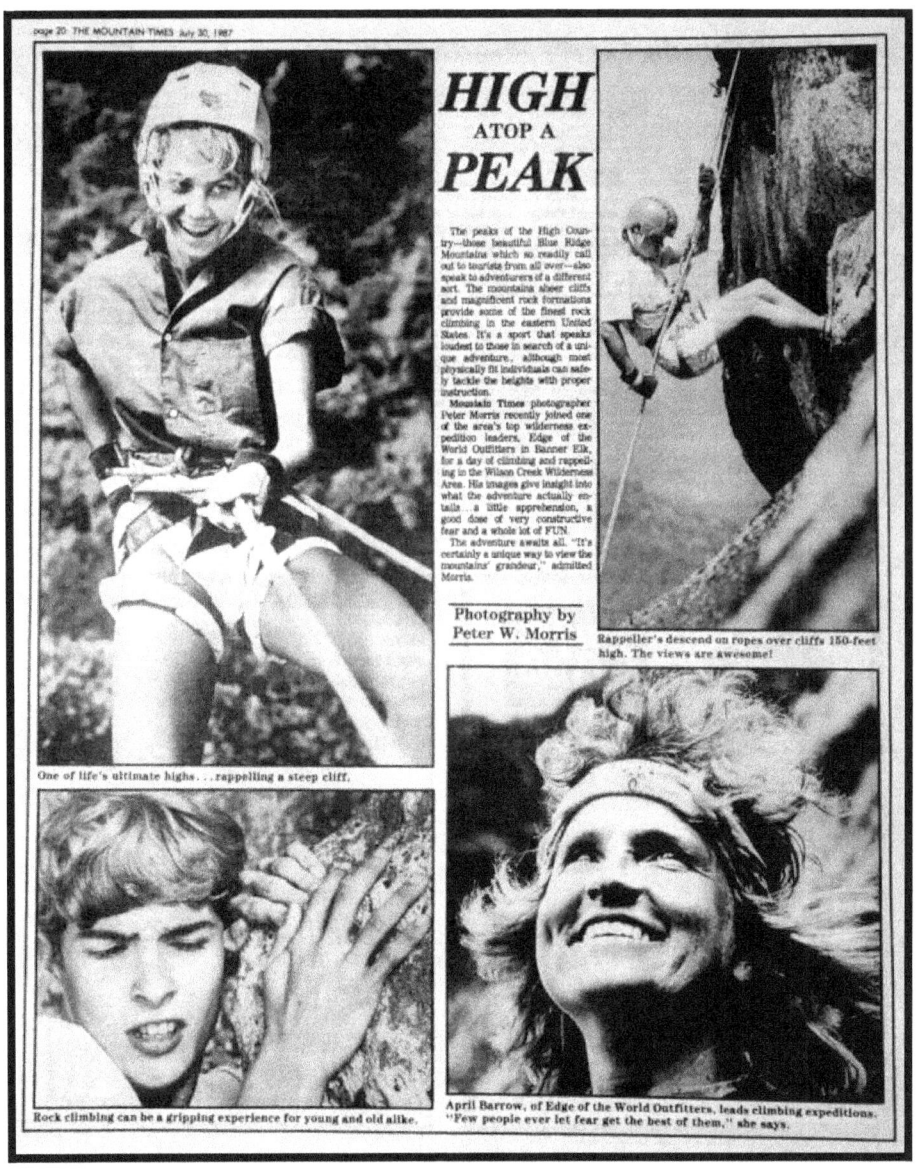

Rock climbing are rappelling offer challenges for the brave in NC's Linville Gorge wilderness area. Here the photographer "shot" from every angle...even shooting while rappelling.

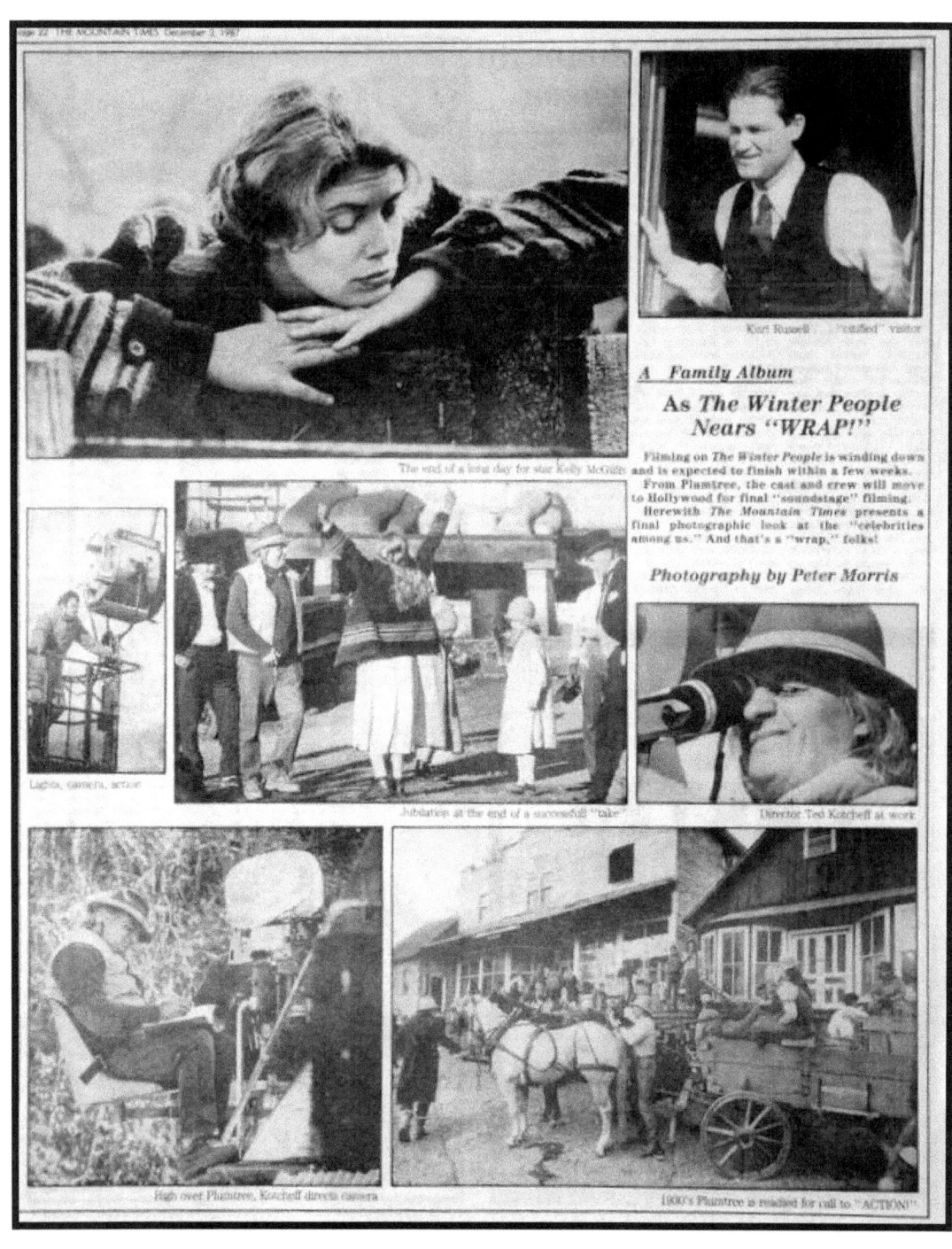

When Hollywood comes to town, shoots are easy, especially with multiple "takes." In *Winter People*, leads Kurt Russell and Kelley McGillis are used to having their pictures taken.

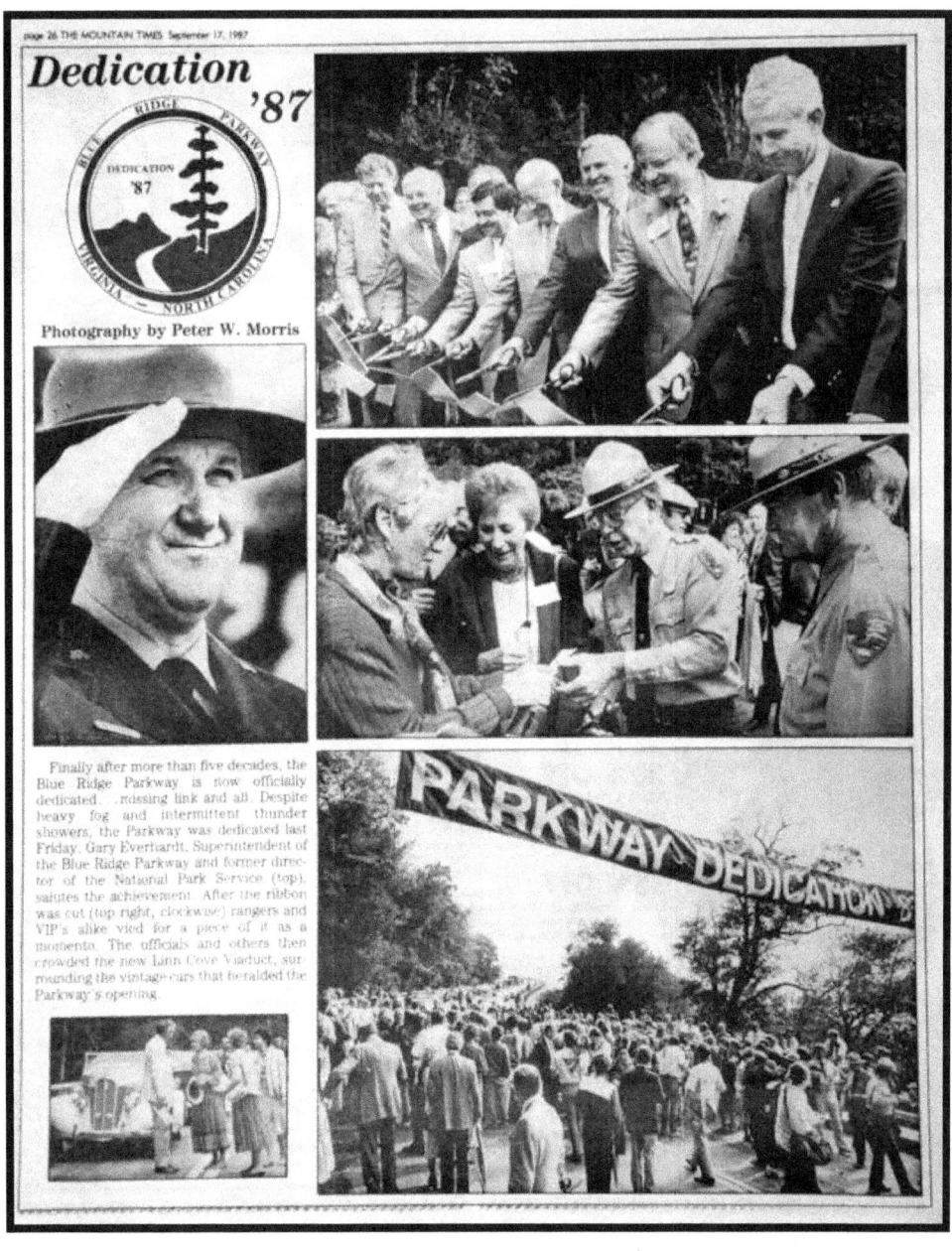

The hundreds of miles which make up the Blue Ridge Parkway were finally completed in 1987, with the span crossing Grandfather Mountain. This is the kind of "grab and grin" that shooters like.

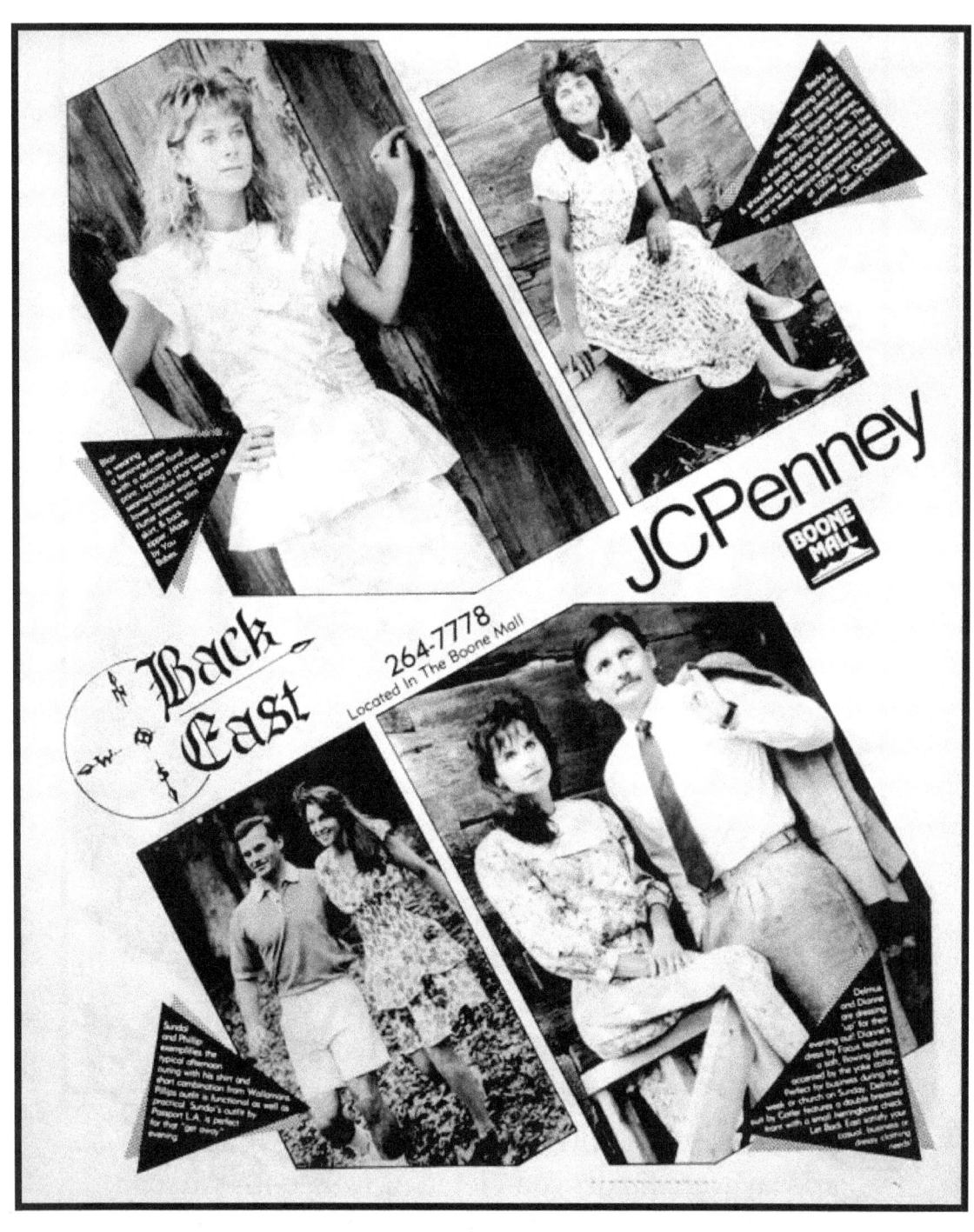

The nice thing about doing these type of photo pages is that you get to hone fashion photography.

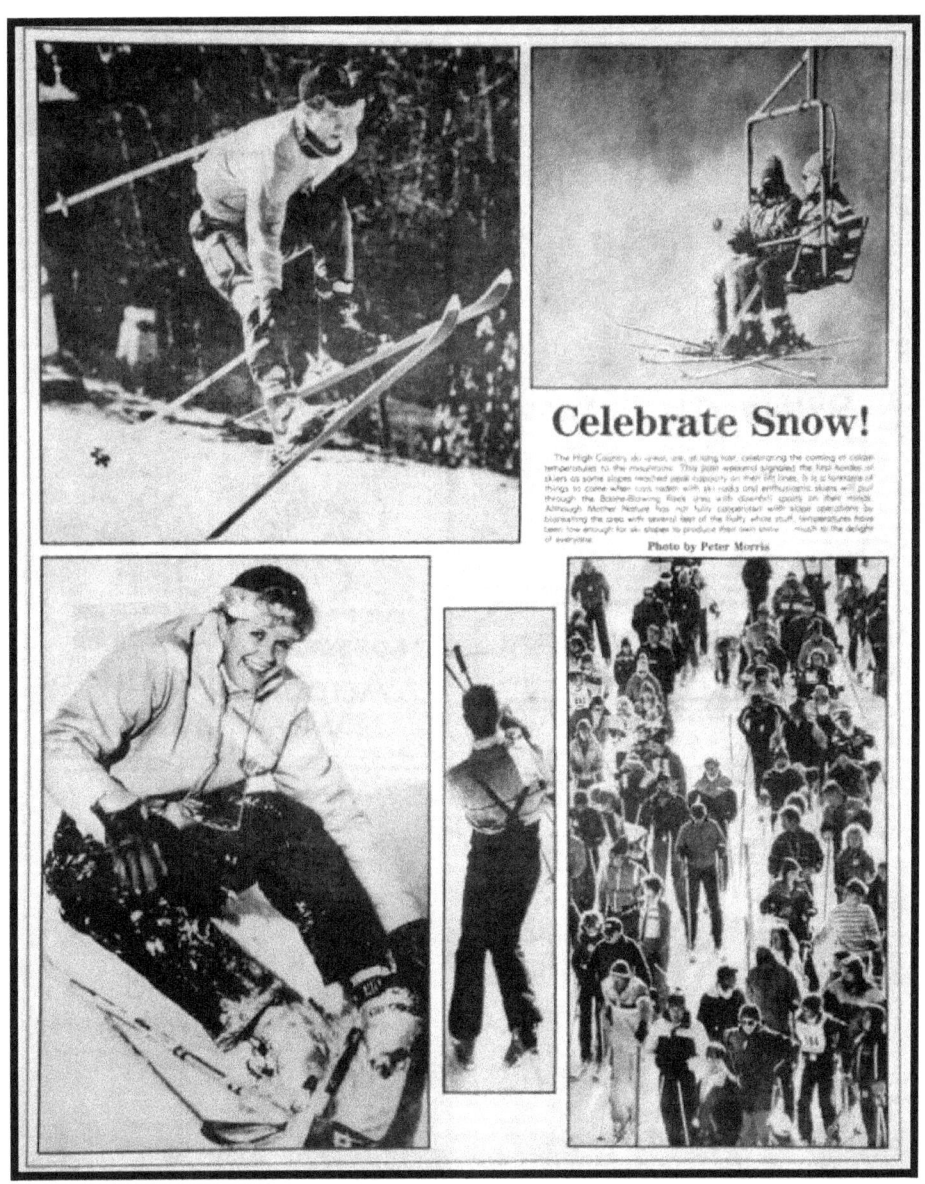

Winter sports are quite popular in the North Carolina mountains and make for easy photo shoots.

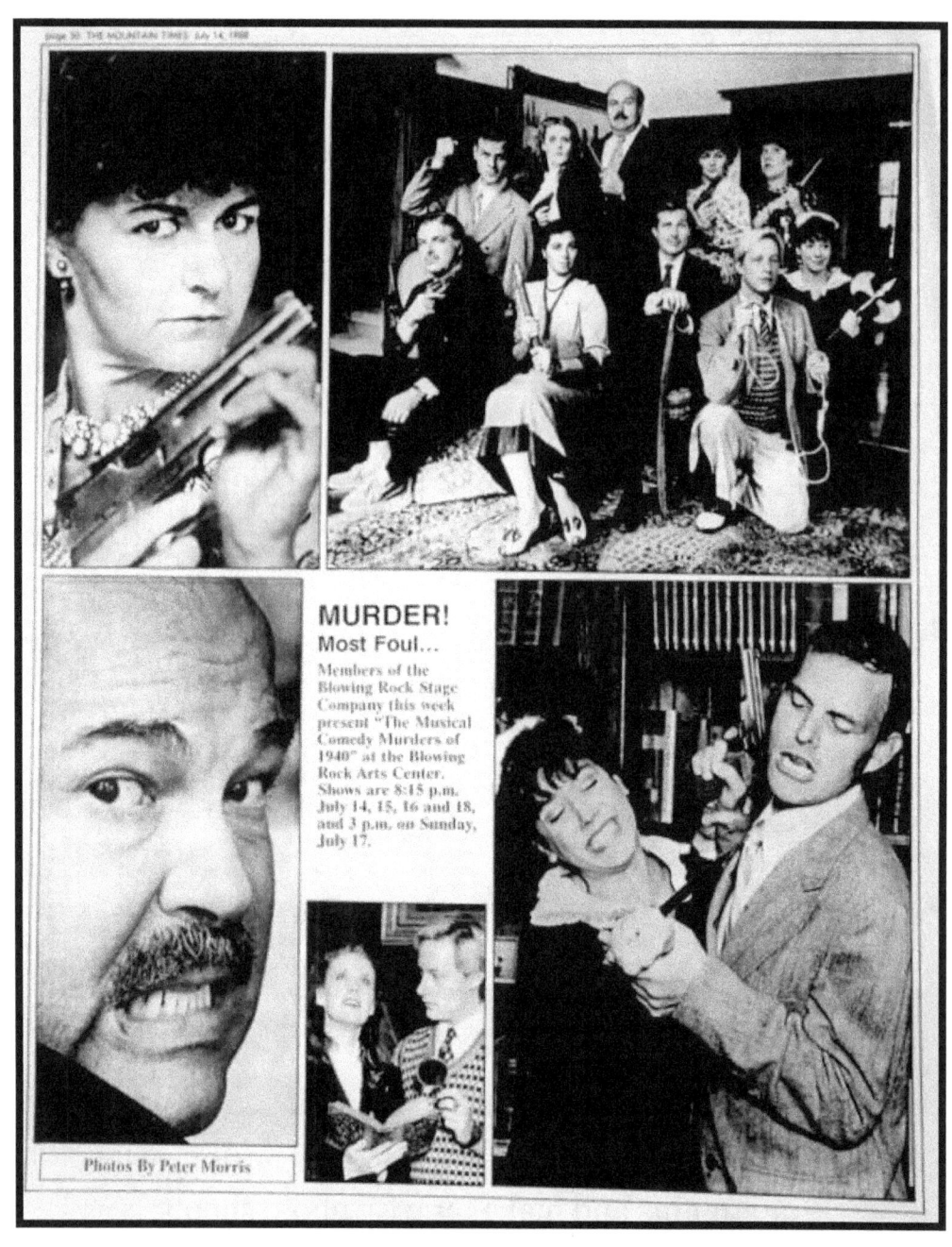

Again, a stage production's "final dress rehearsal" provides all the elements for an exciting page.

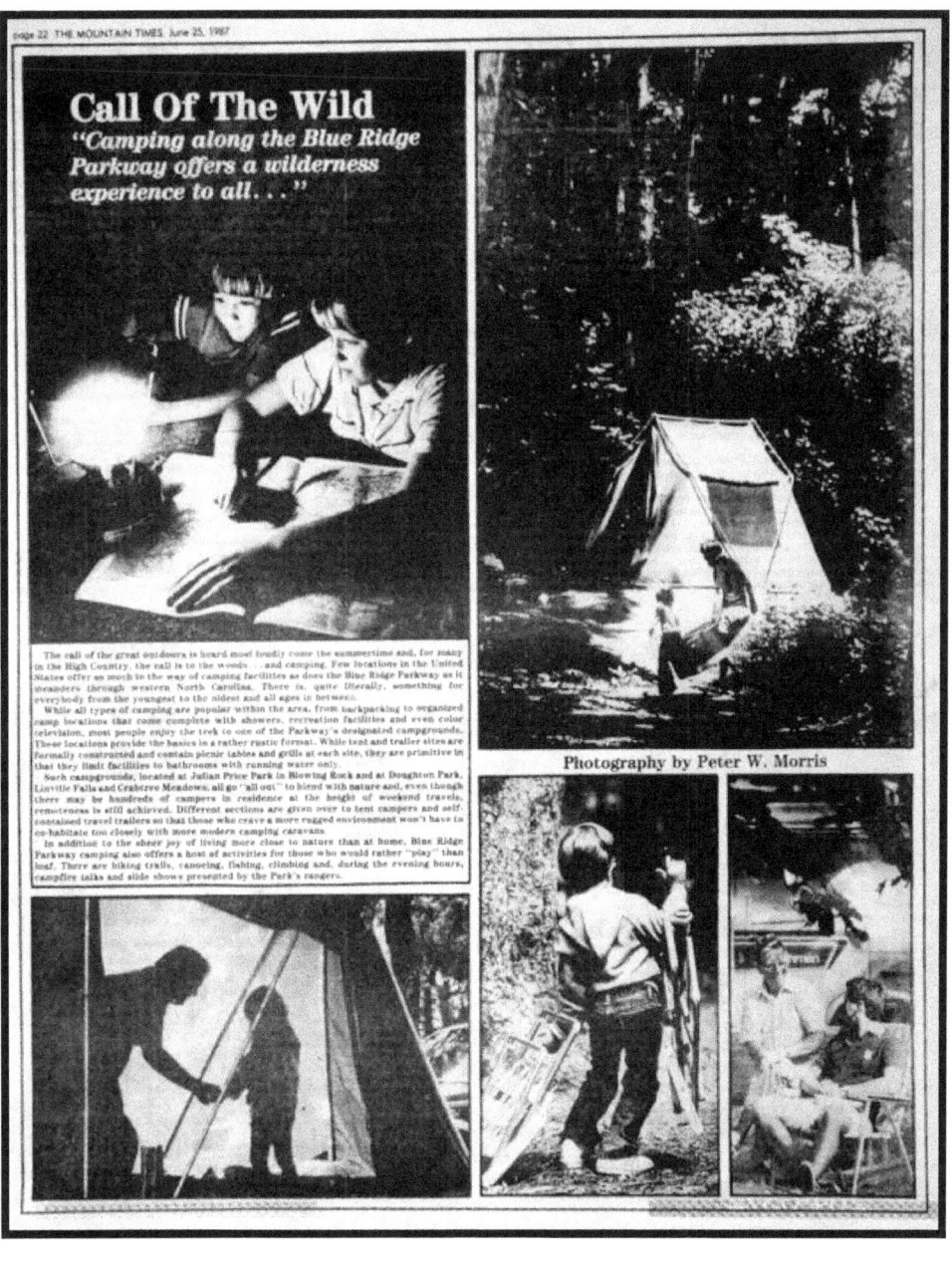

The anchor shot here is of the two children at a nighttime camp site lit only by the light of a Coleman lantern. Basically, it sets the mood for the entire page.

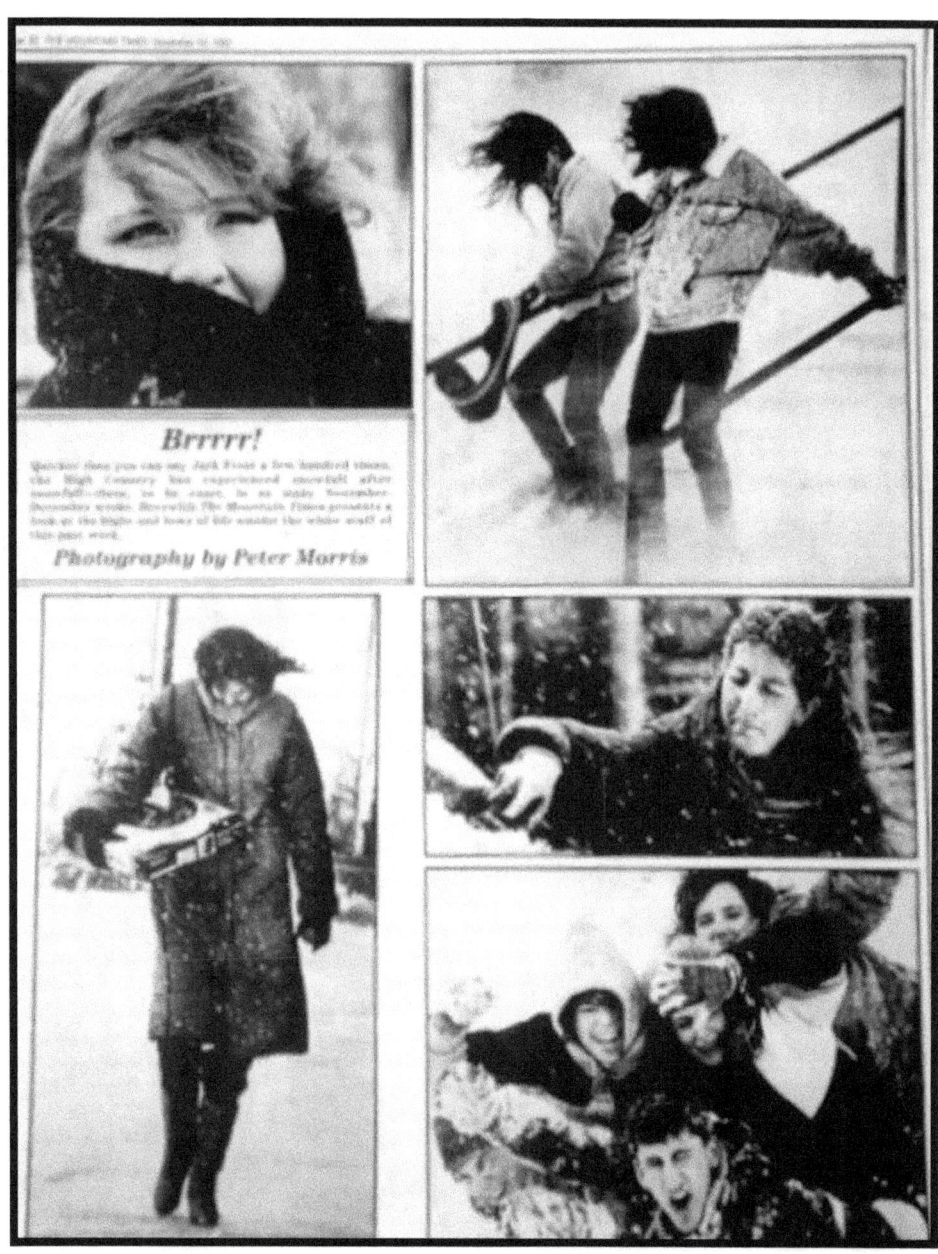

"Burrrr, it's cold outside baby!" The impact picture here is the two girls heading into the elements. This certainly isn't a setup, and it took several frames to get it right.

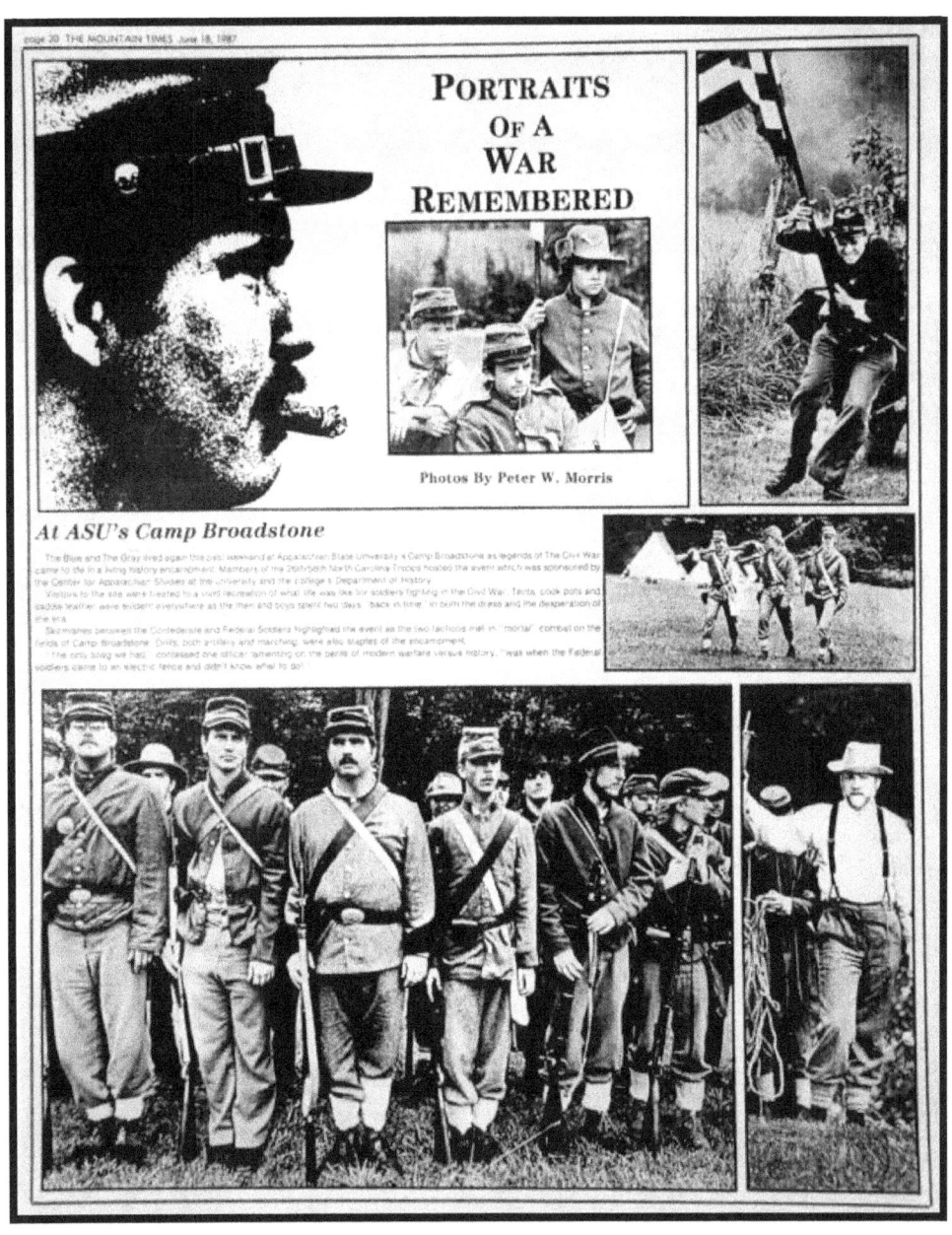

In picture pages, it's so important to have one picture stand out so as to enhance the overall shoot. Enter a man with a cigar, with tonal values left out.

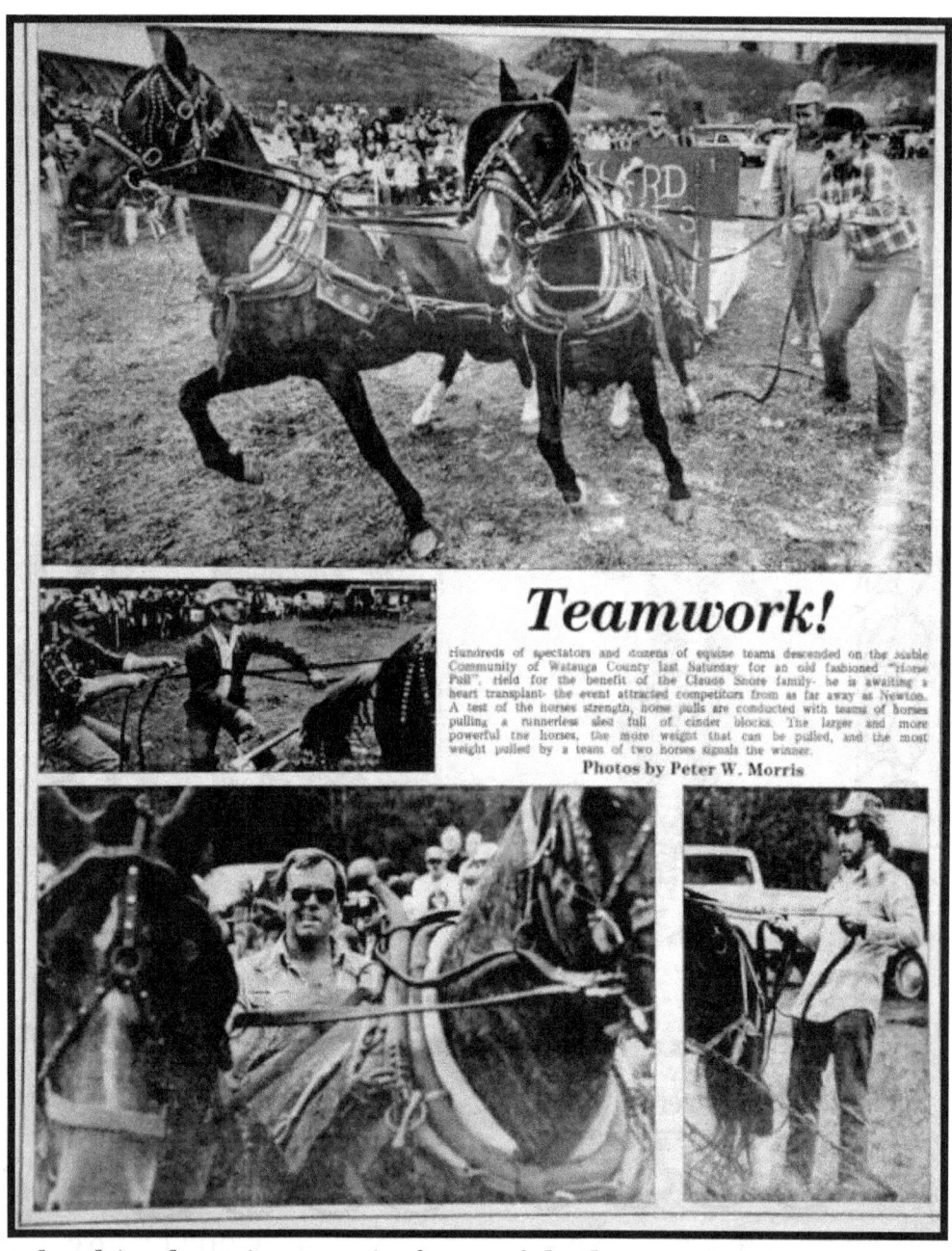

The thing here is to get in front of the horses for the drama of the shot. The reason photojournalists' succeed is because they often court danger to get the most impactful image.

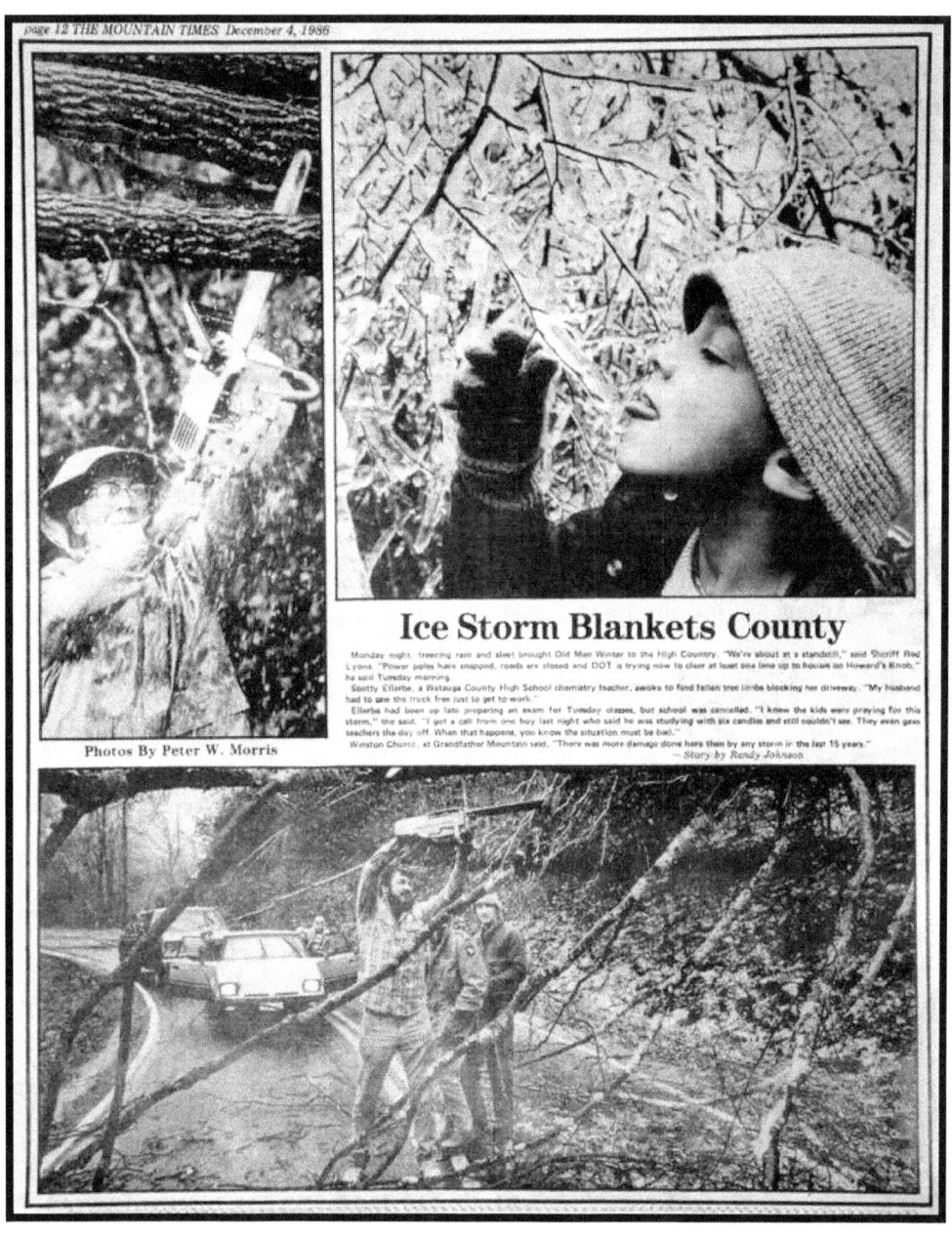

It only took three images to tell this story. My own car in the distance helped tremendously for showing the effects of an ice storm.

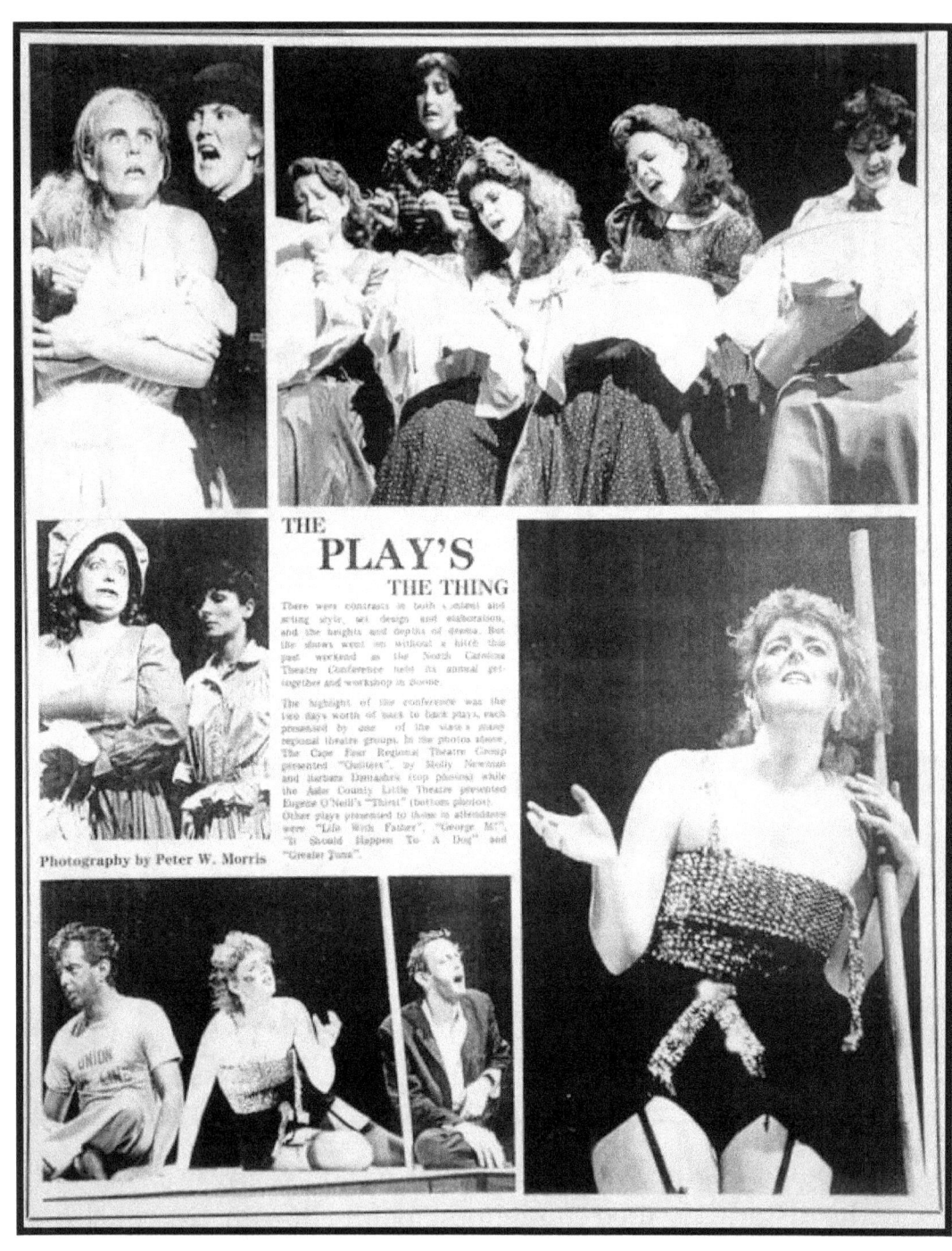

Yes, the play *is* the thing! Many "stage moods" are seen in this page.

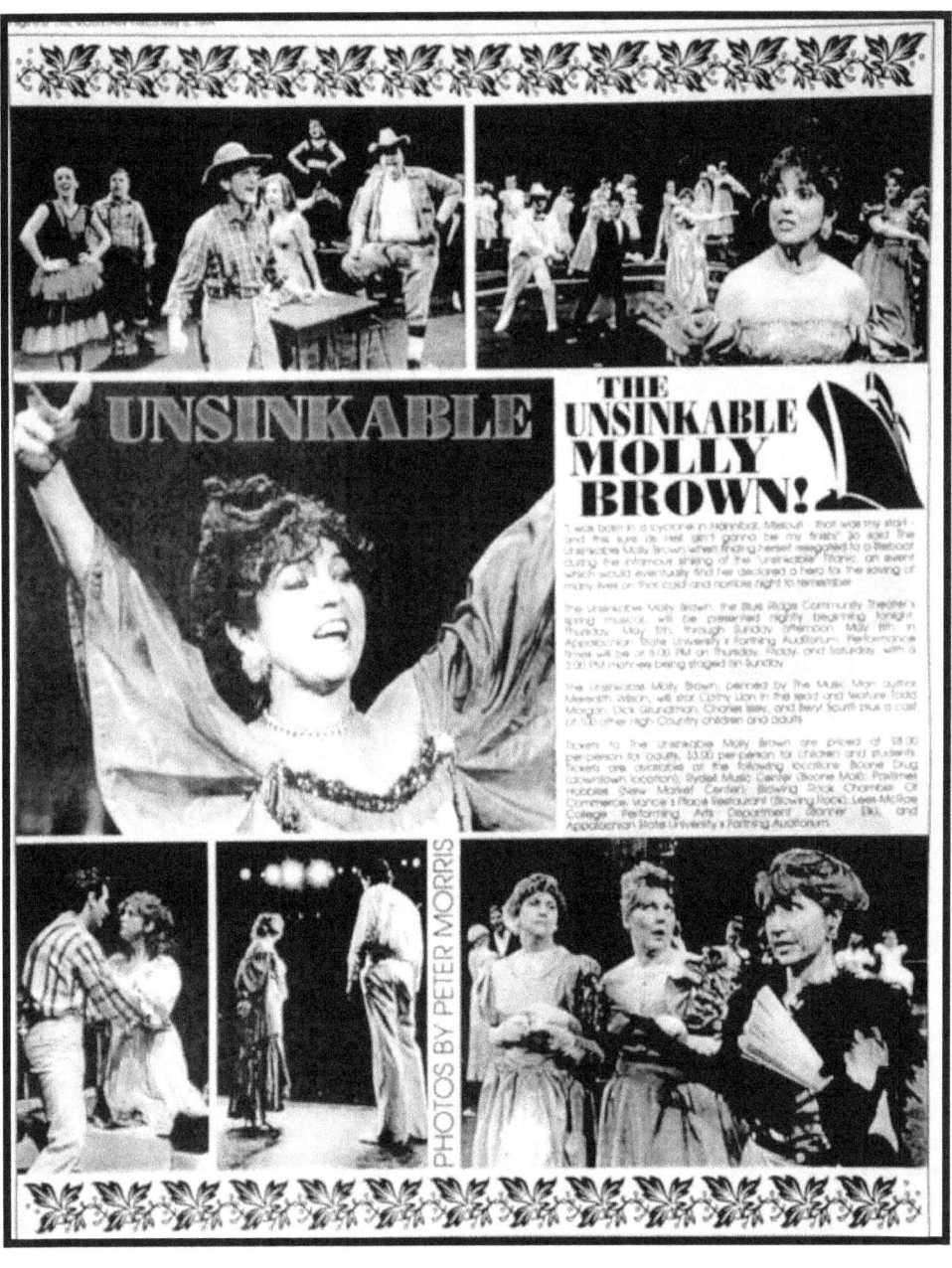

This production would probably have been better presented without the "ivy" borders! The boat was enough.

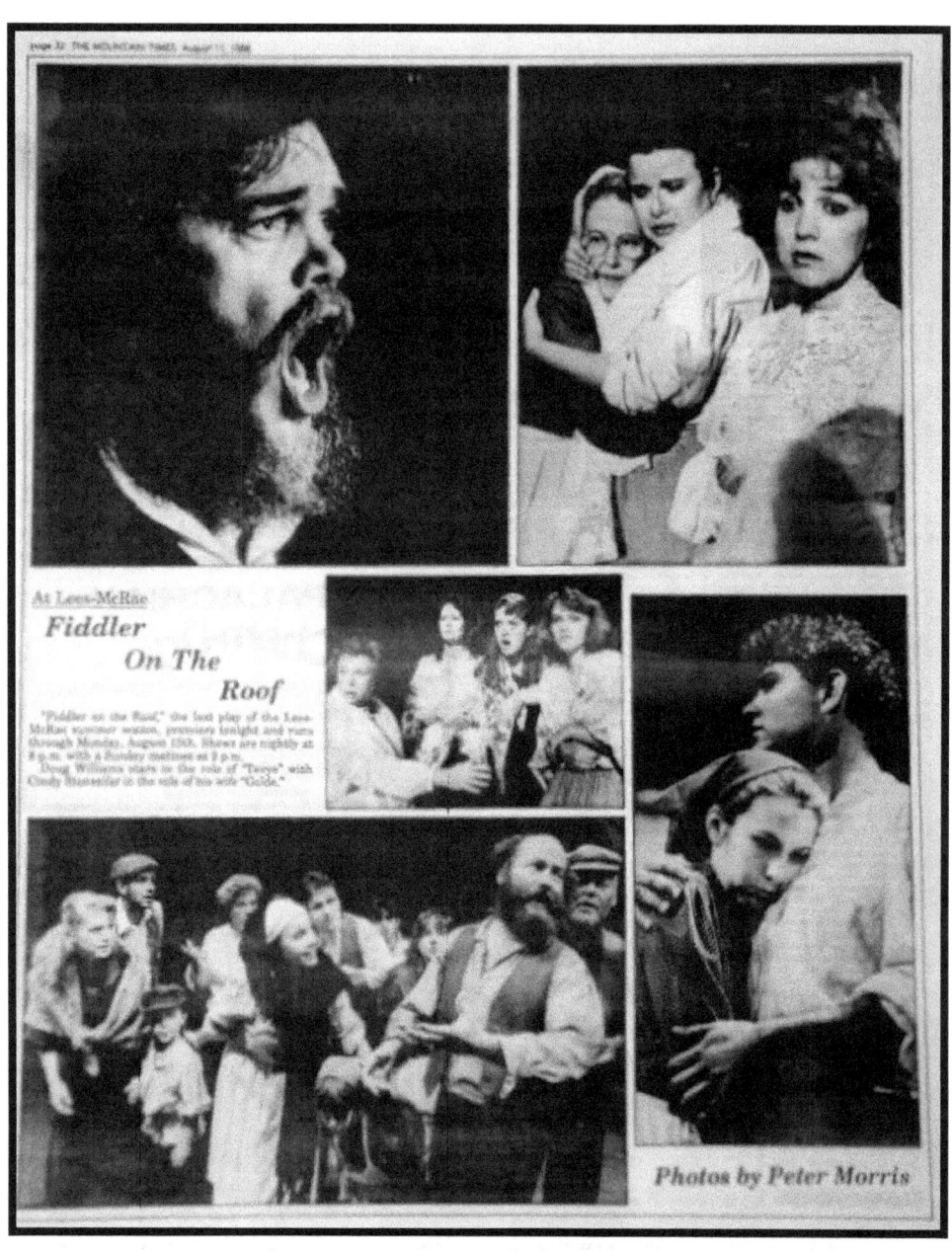

The close-up of the lead actor is powerful, certainly the best story-telling aspect of this page.

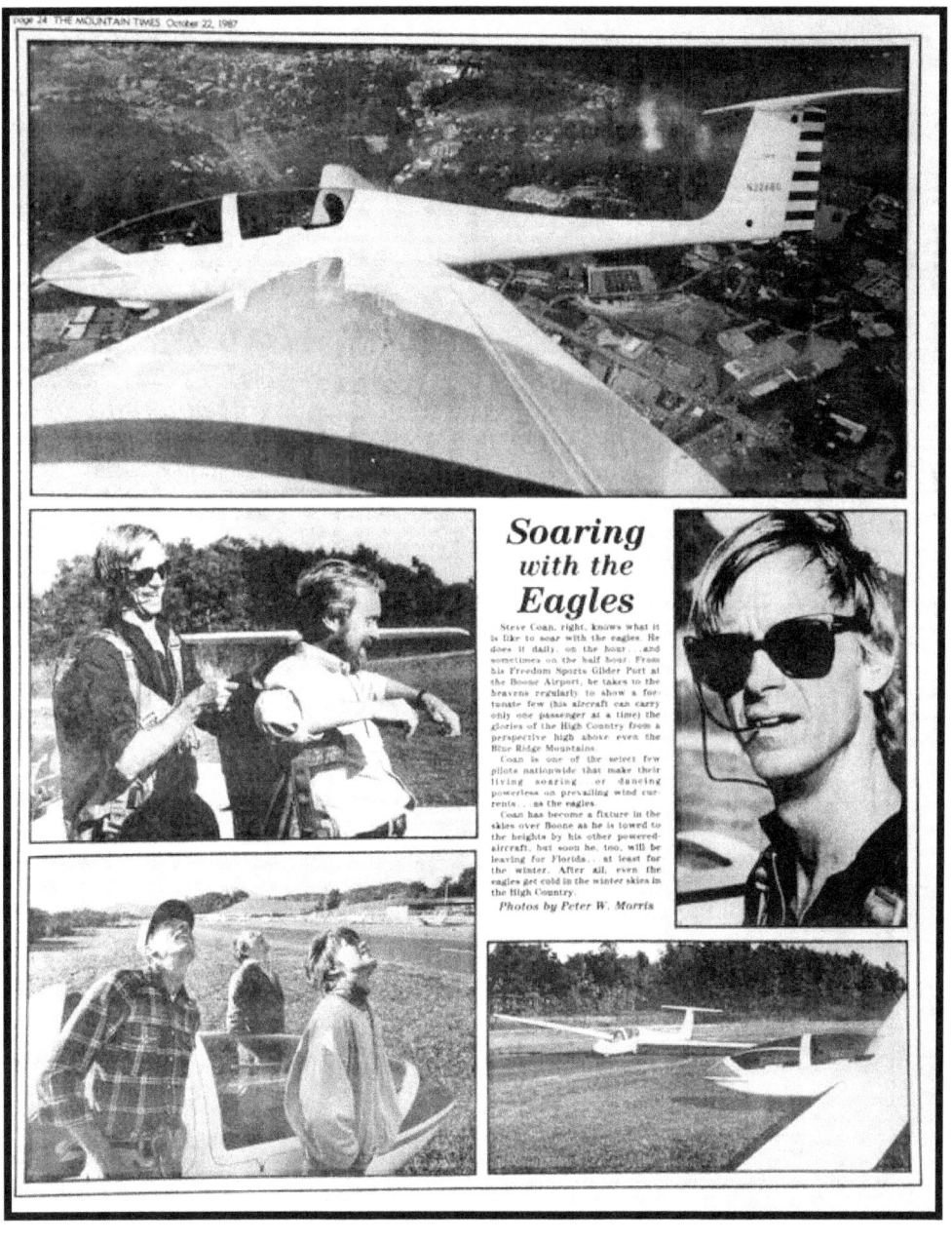

This photo shoot proved deadly. My assigned flight was taken by another, who died instantly when the glider crashed on takeoff. A wingtip-mounted camera was used in the top picture.

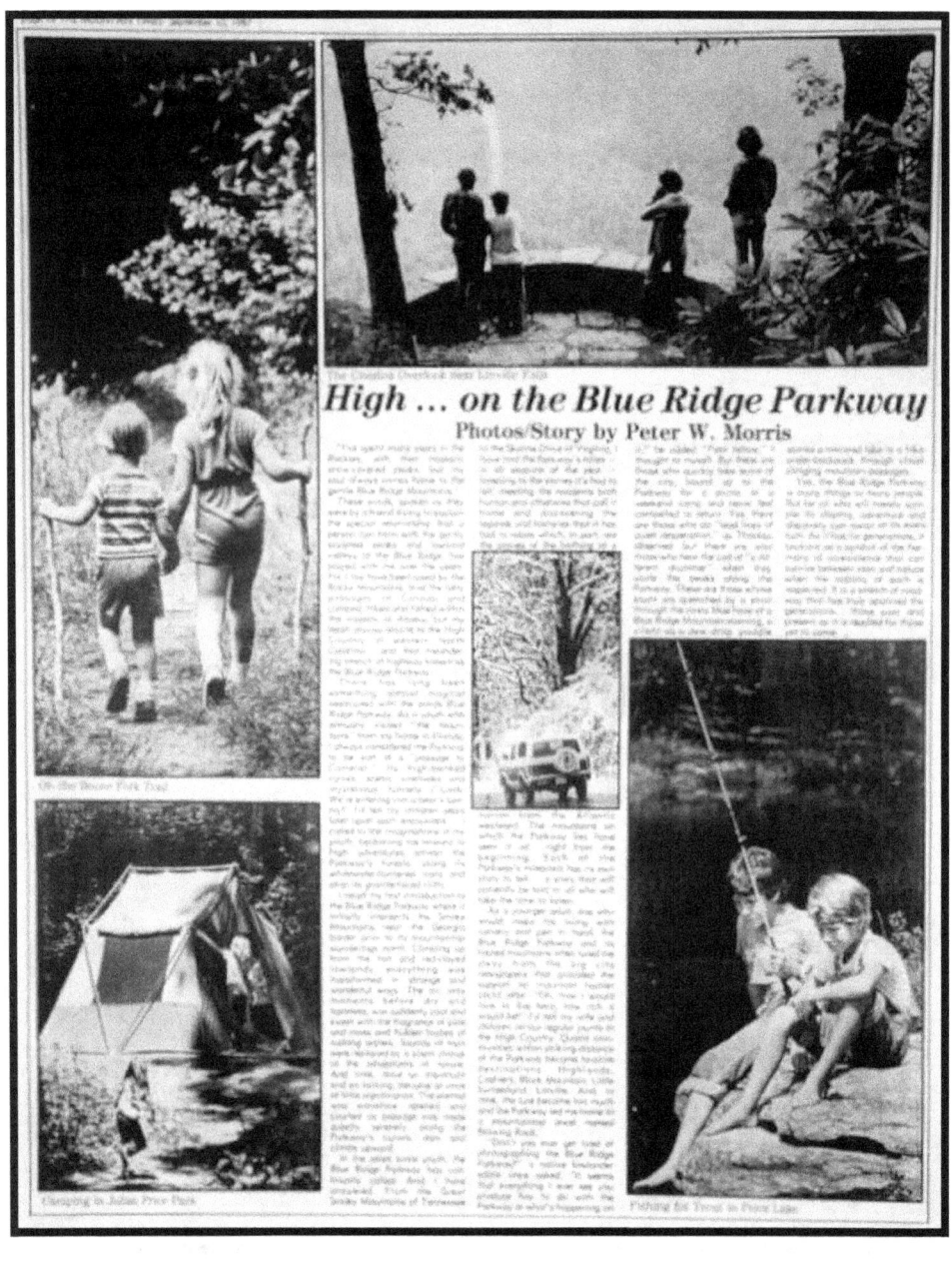

This Norman Rockwell-inspired elements of this page are sure to please the most hardened of viewers.

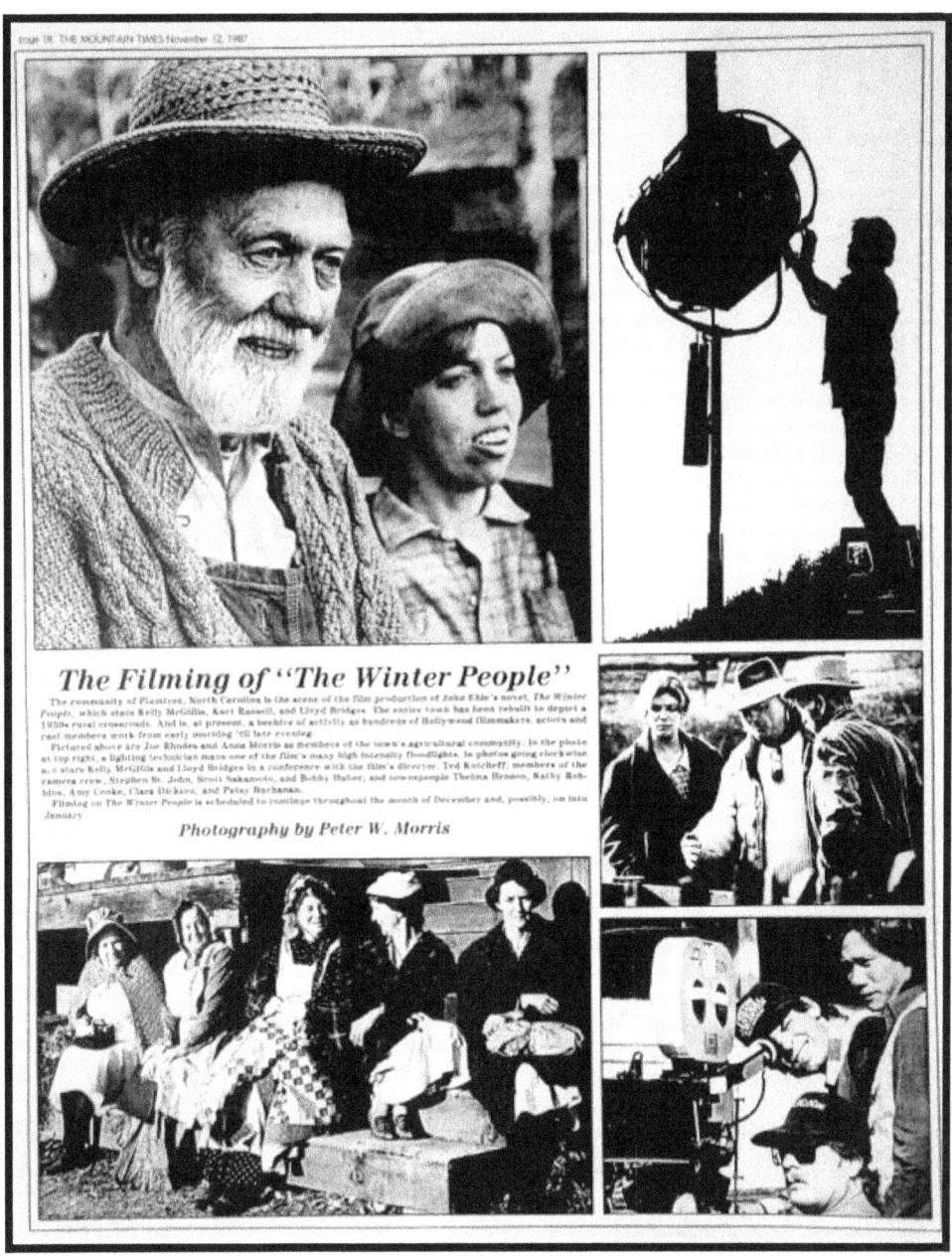

Movie-making is big business in North Carolina, which is among the "top four" of California, New York and Florida.

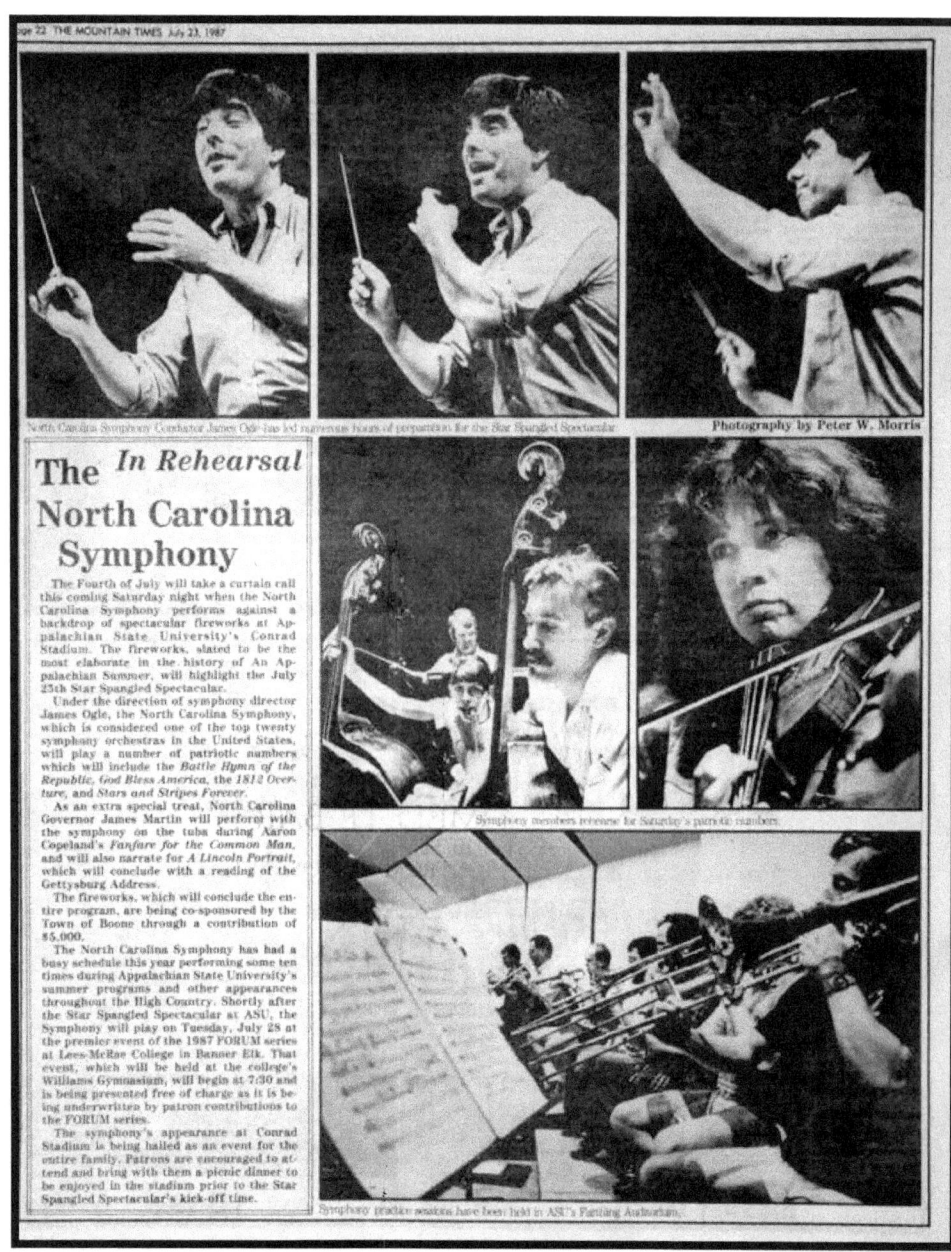

The conductor at top of the page tells the story. Occasionally, I've photographed conductors with a "light wand" in available darkness.

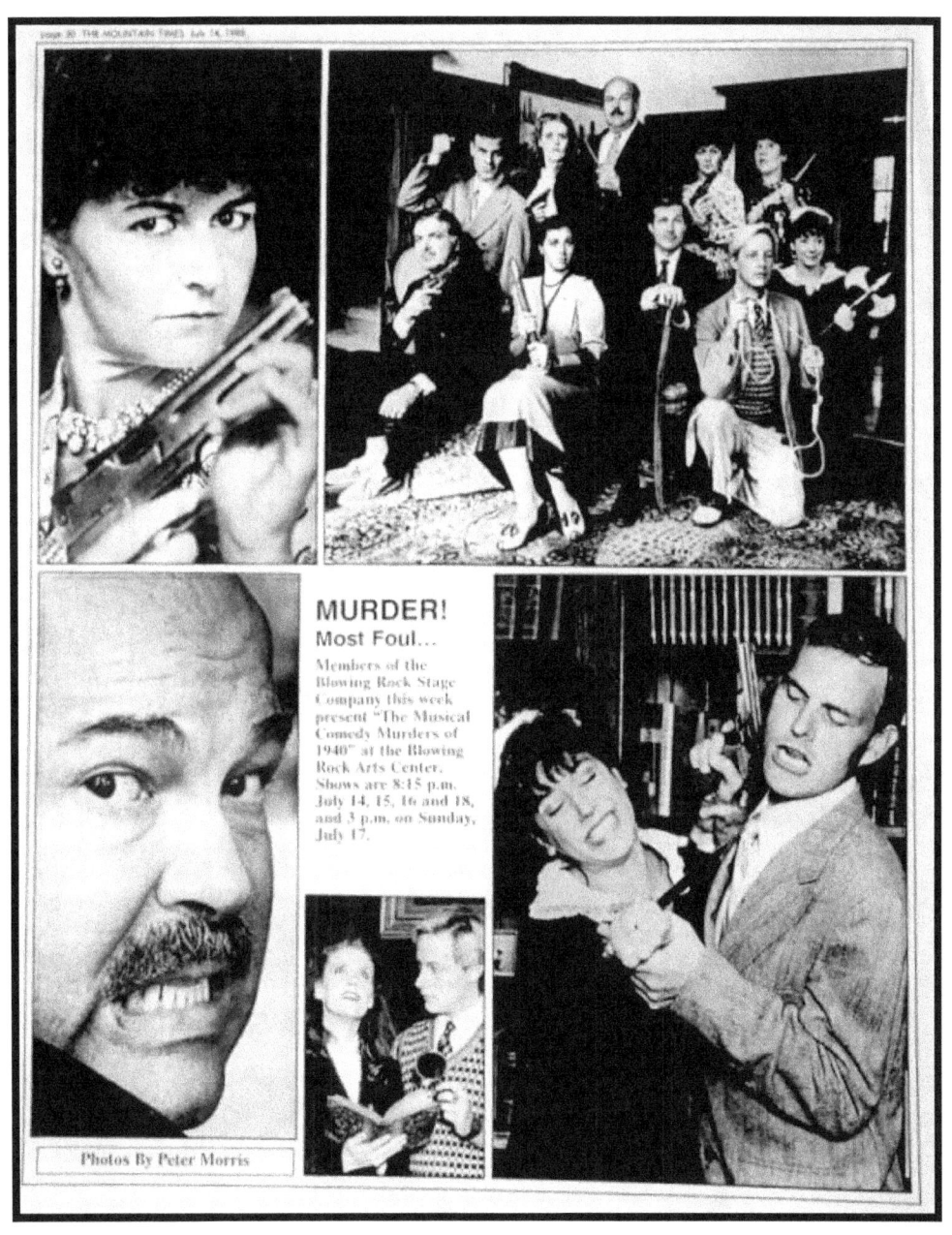

This photo page was shot in a re3al castle in Blowing Rock, NC. Sadly, I didn't show much of this unique staging.

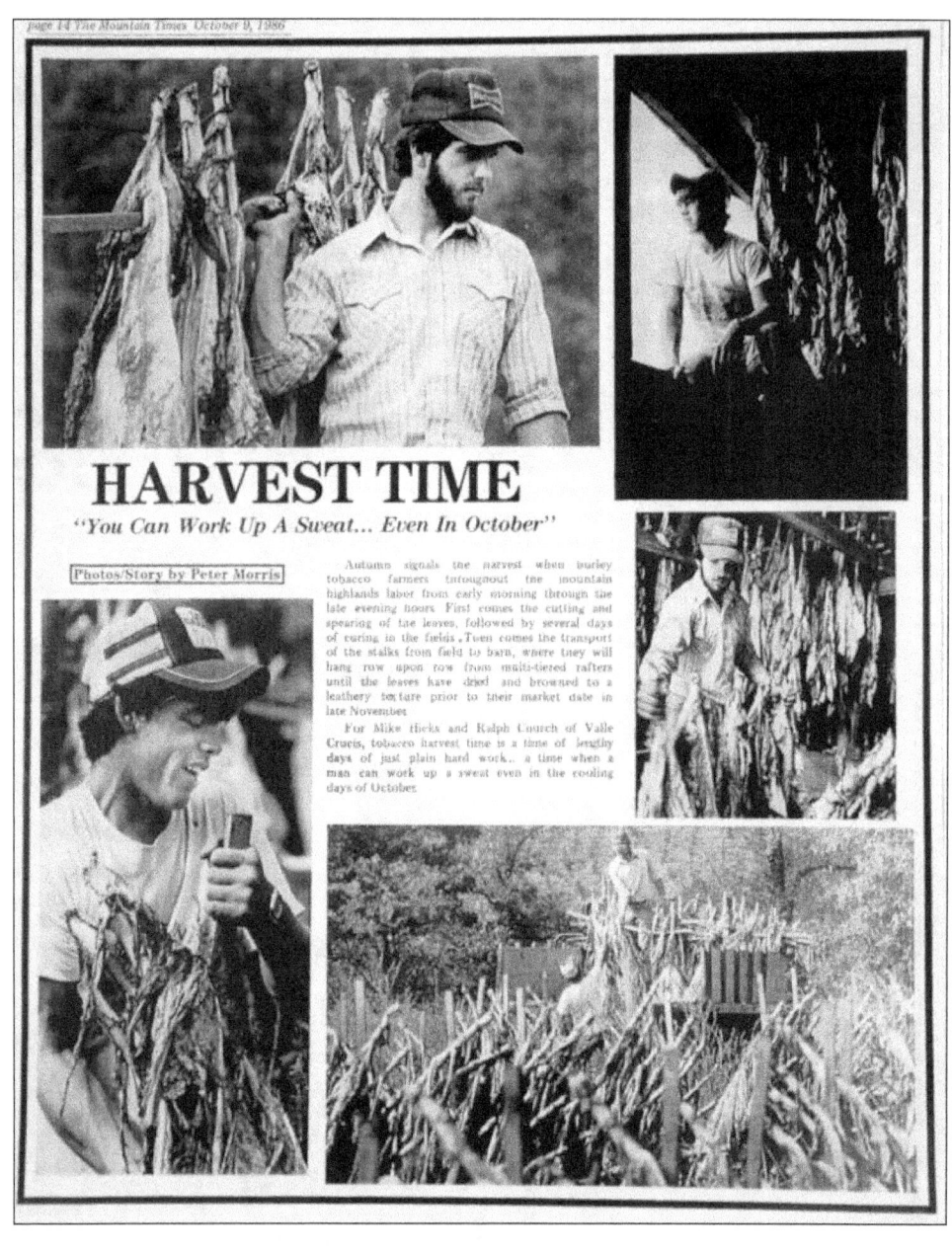

My first picture page while employed at the **Mountain Times**. Some of these images required me to climb into the rafters of the tobacco "drying barn."

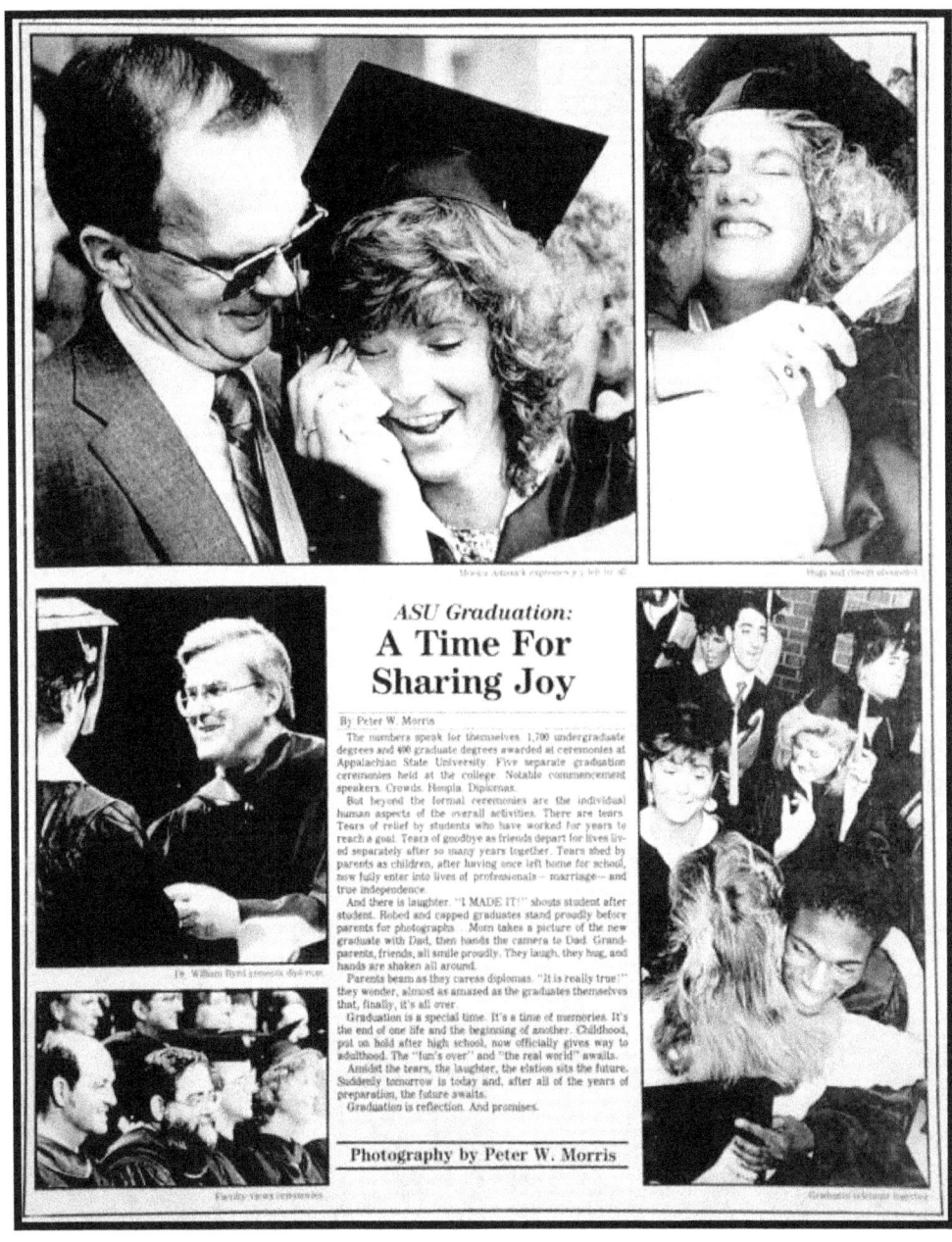

Capturing the emotional aspects of college graduation conveys to one and all the glorious end of years of study.

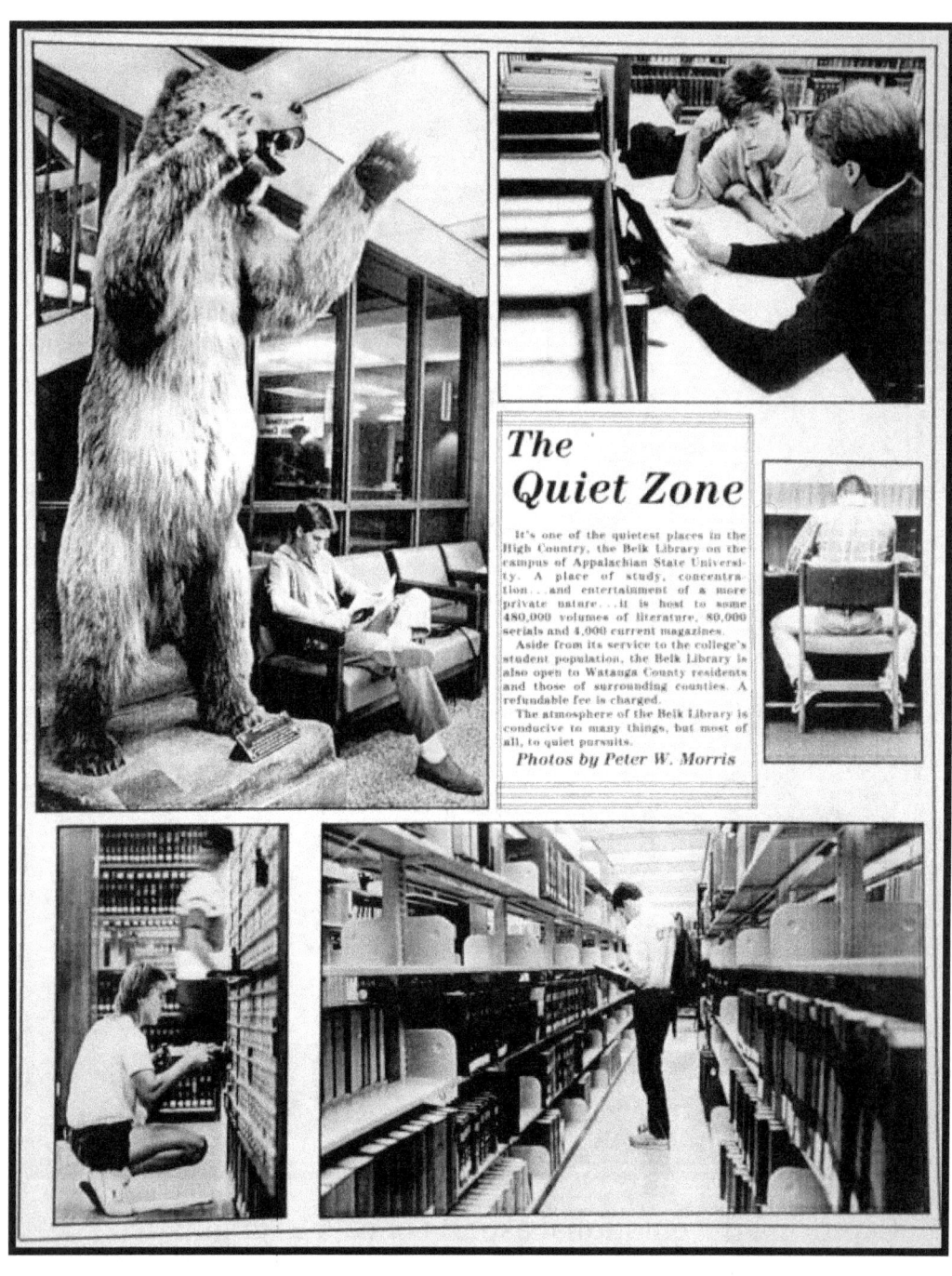

One of my most enjoyable photo assignments is going to the library, where good images are "easy picking."

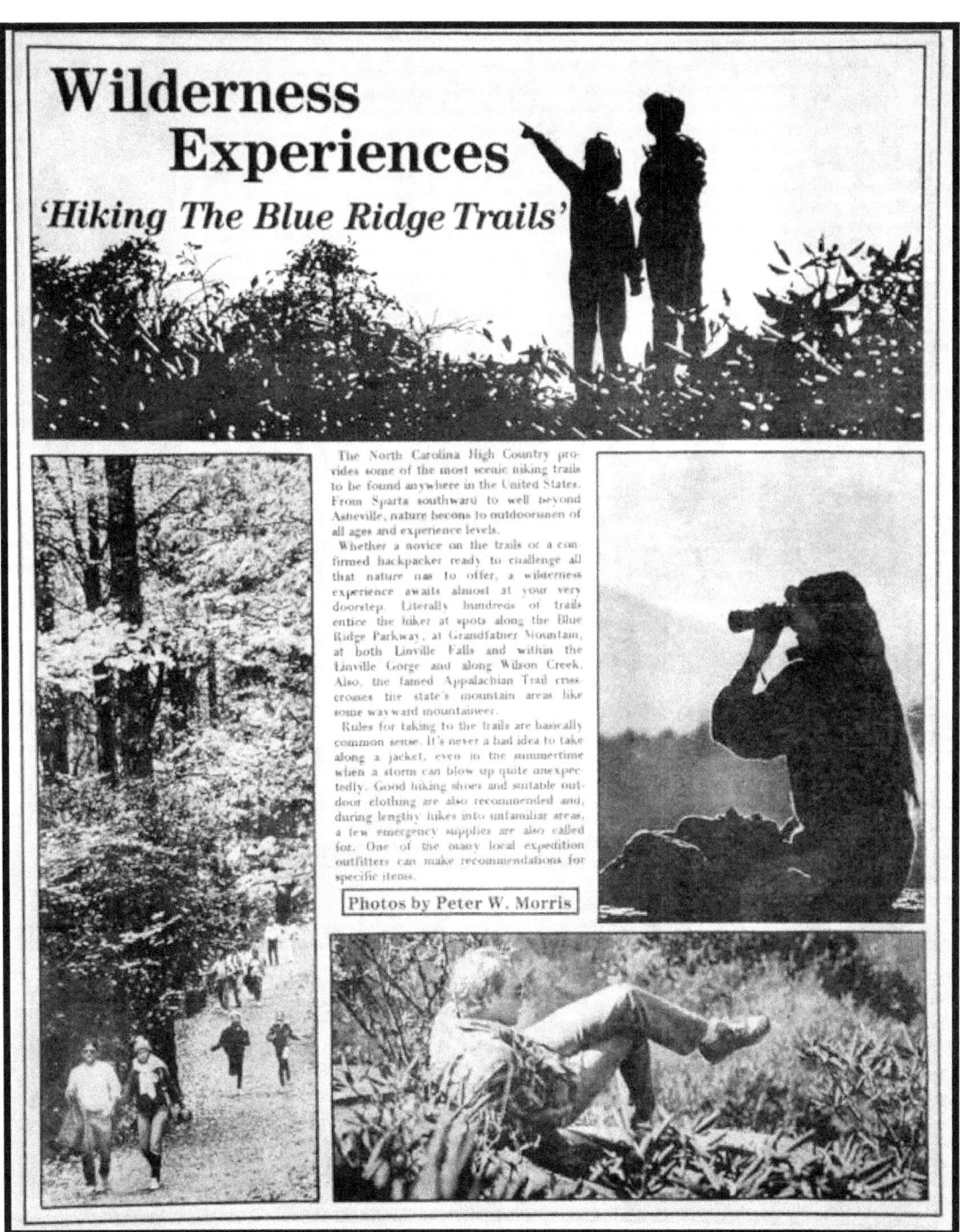

The top photo in this spread found many uses, one on my official business cards.

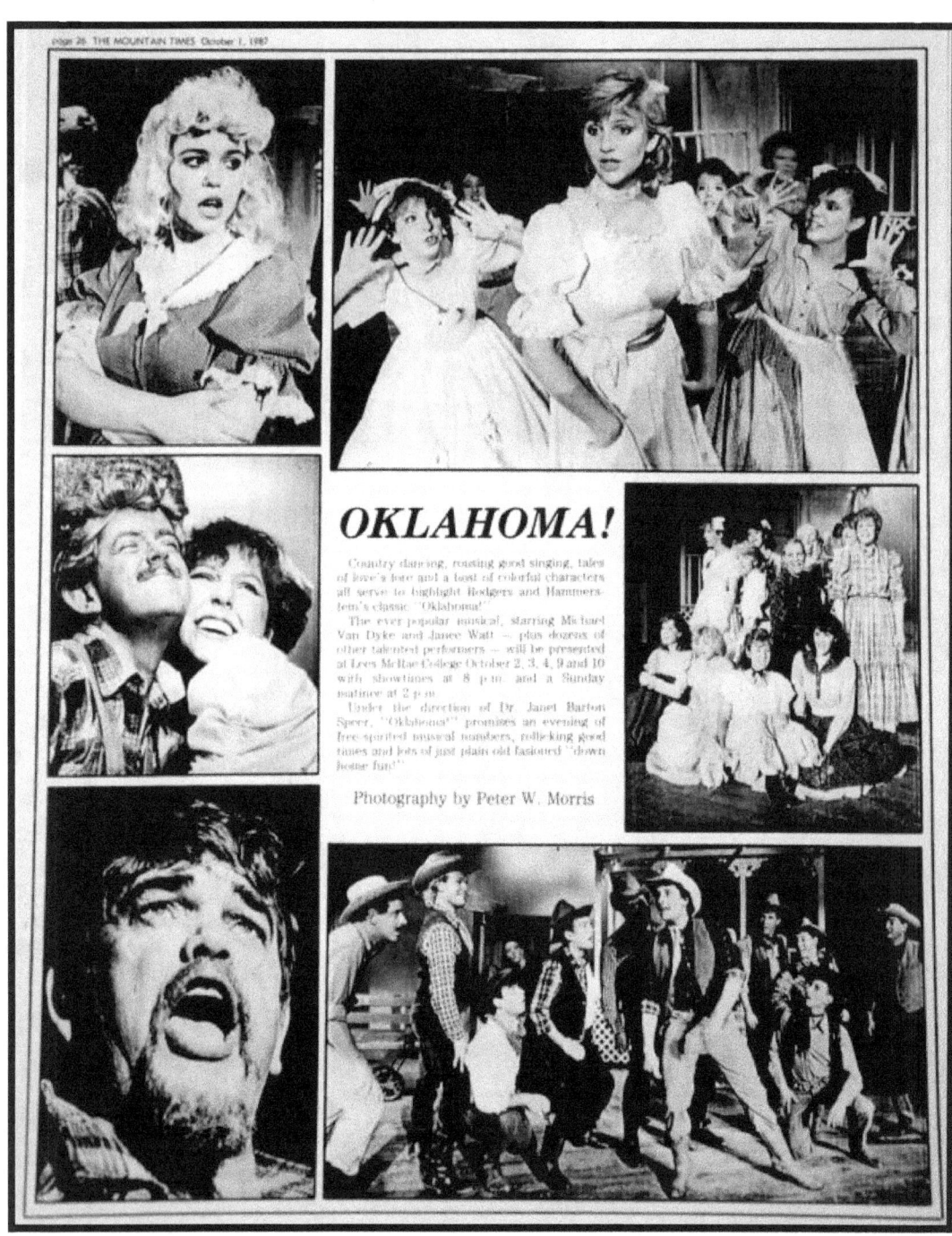

Enough said about stage productions; I love 'em!

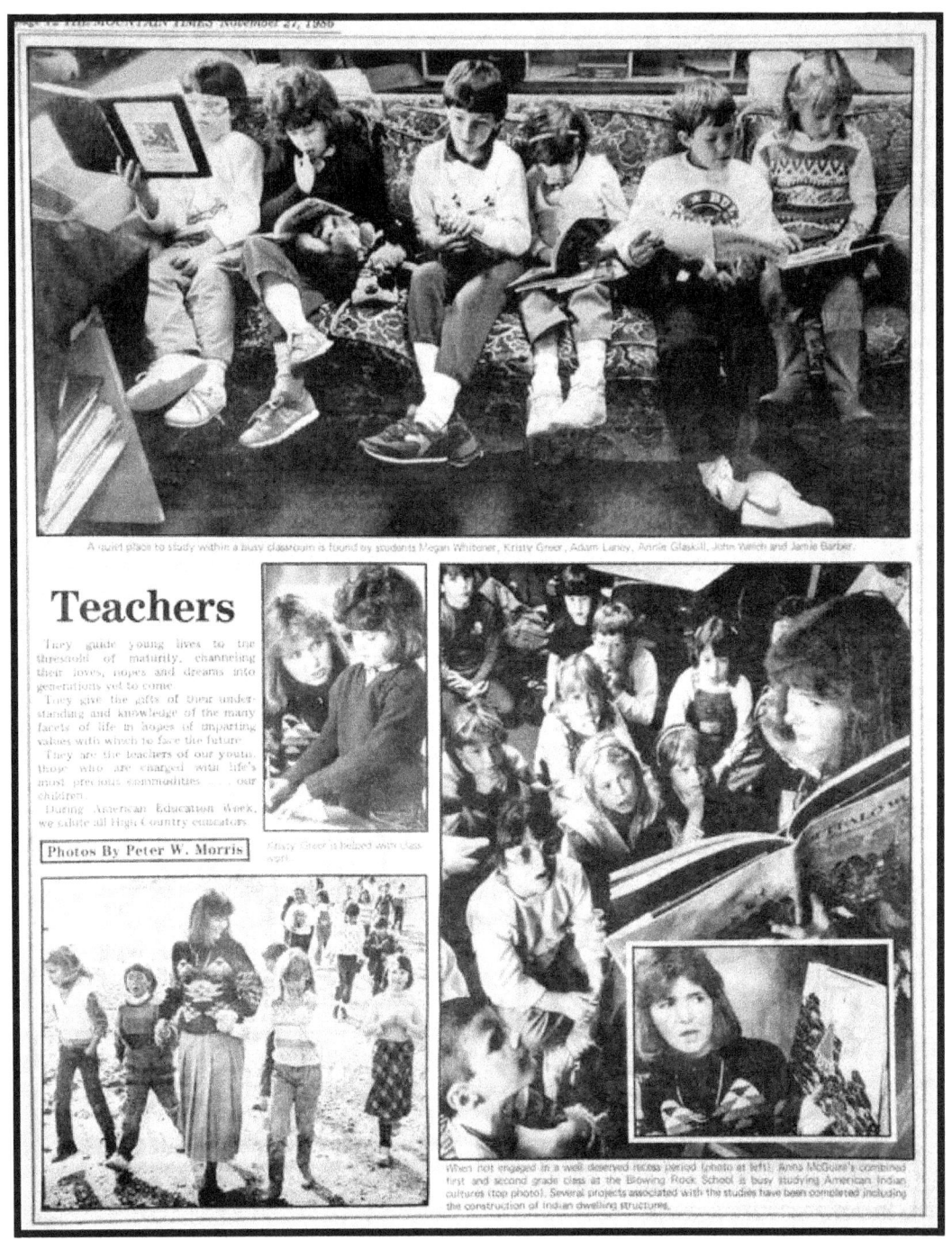

Note the photo which is set into another photo. It's all about telling the story in a unique way.

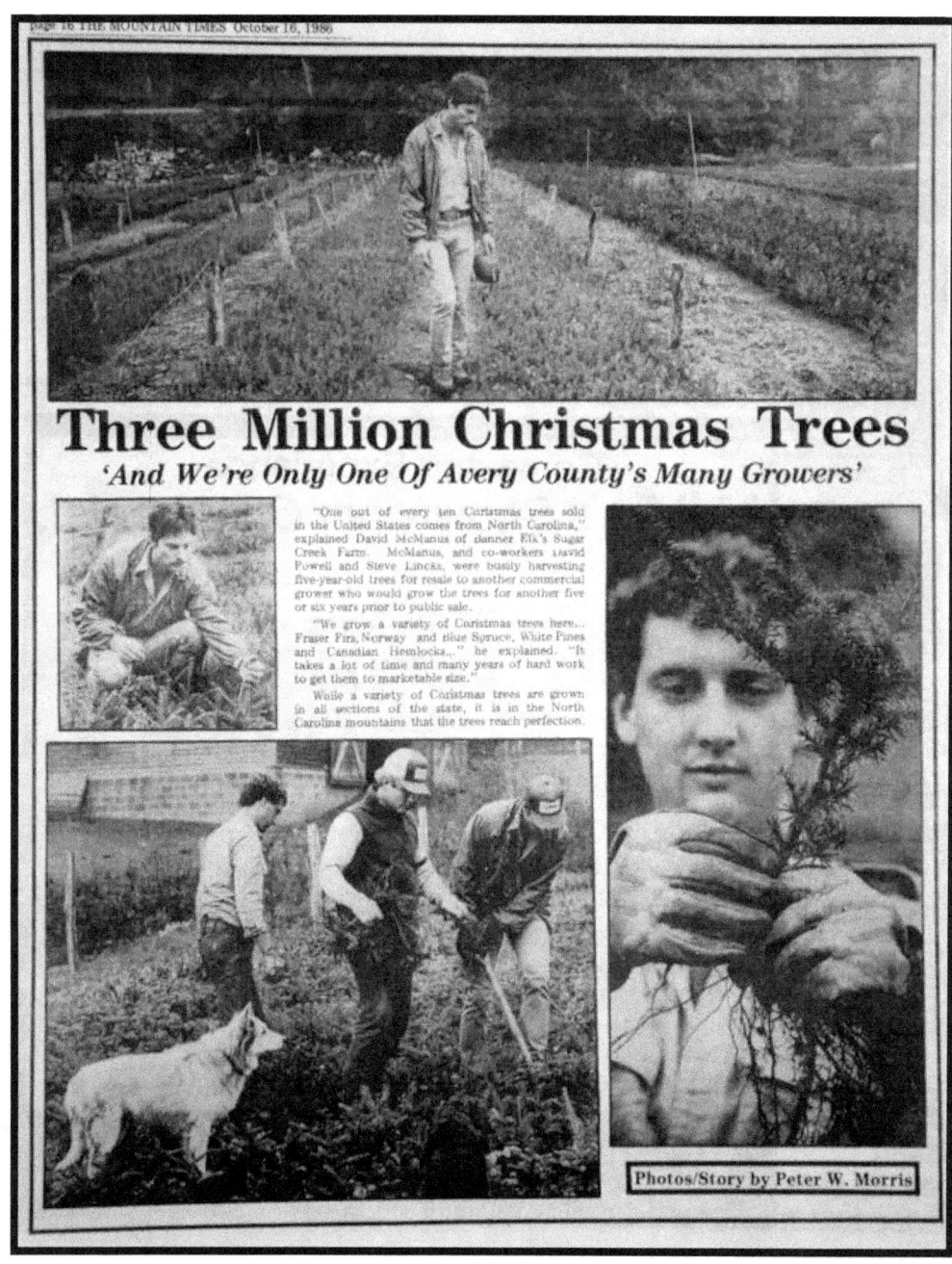

North Carolina tree farmers are a constant source of photographs, especially around Christmas time.

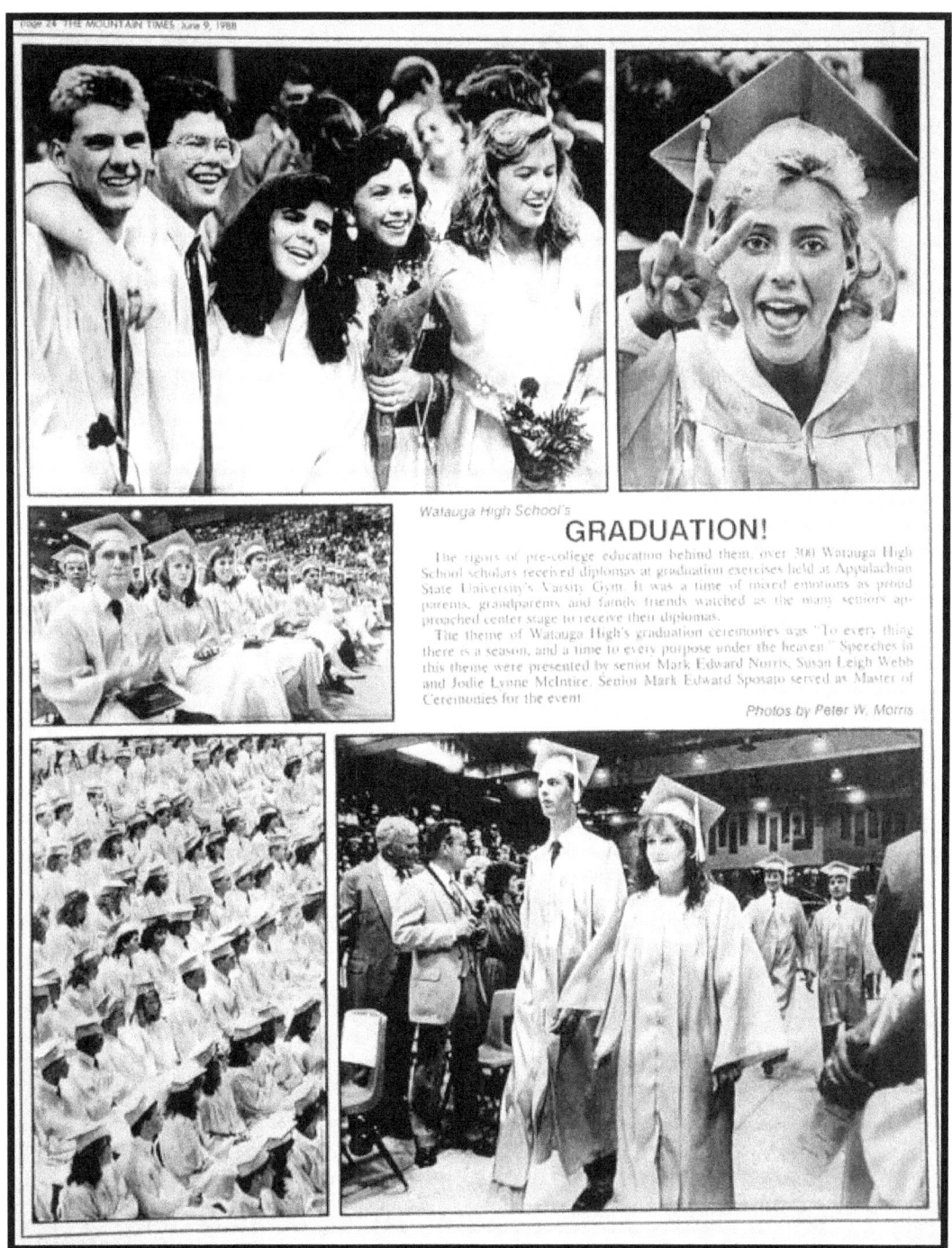

The photo ops at a graduation are all but unlimited. Shoot for the joy expressed on faces, in families.

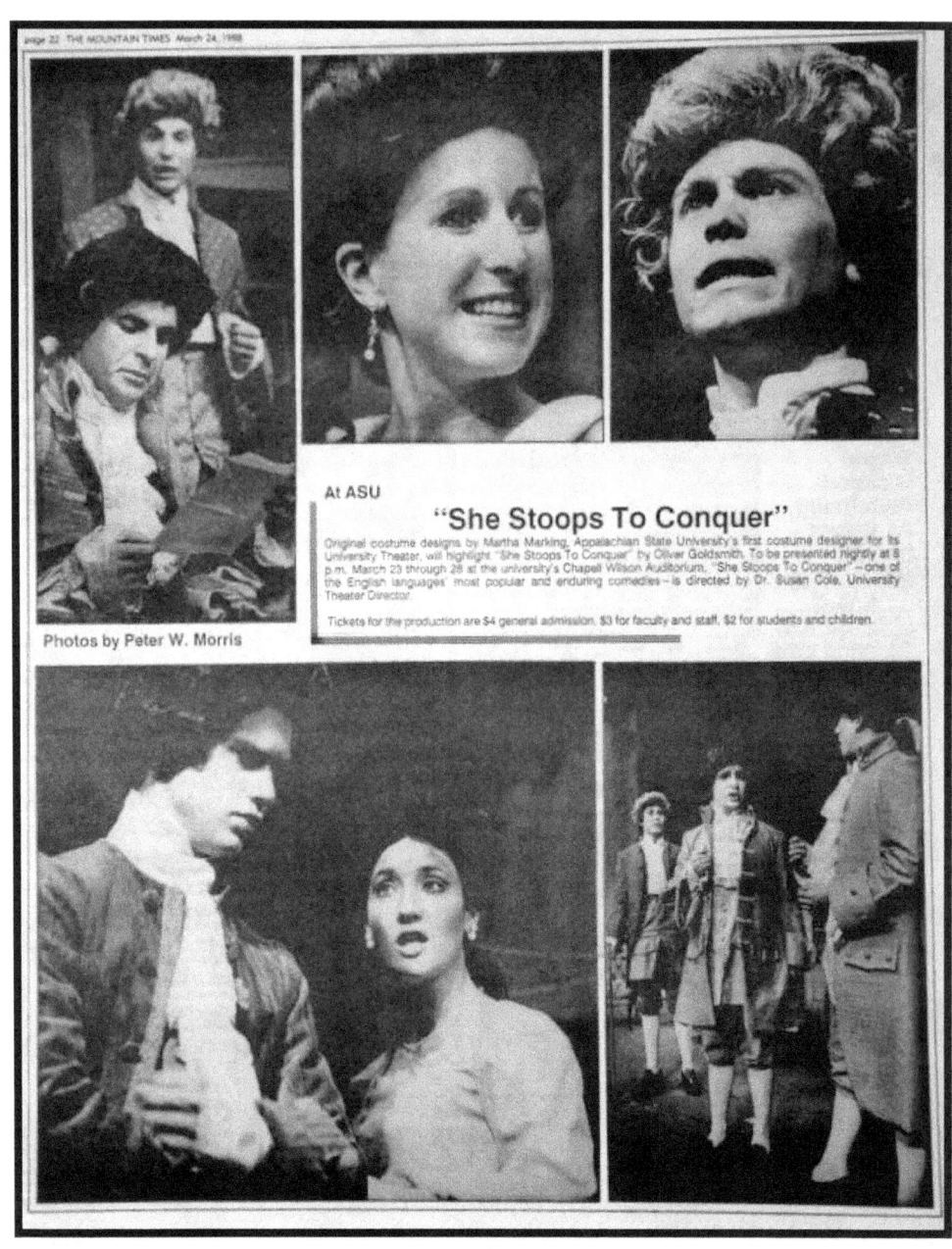

This was not a particularly easy play to shoot, not much action. Thus, a rather "stuffy" layout of characters.

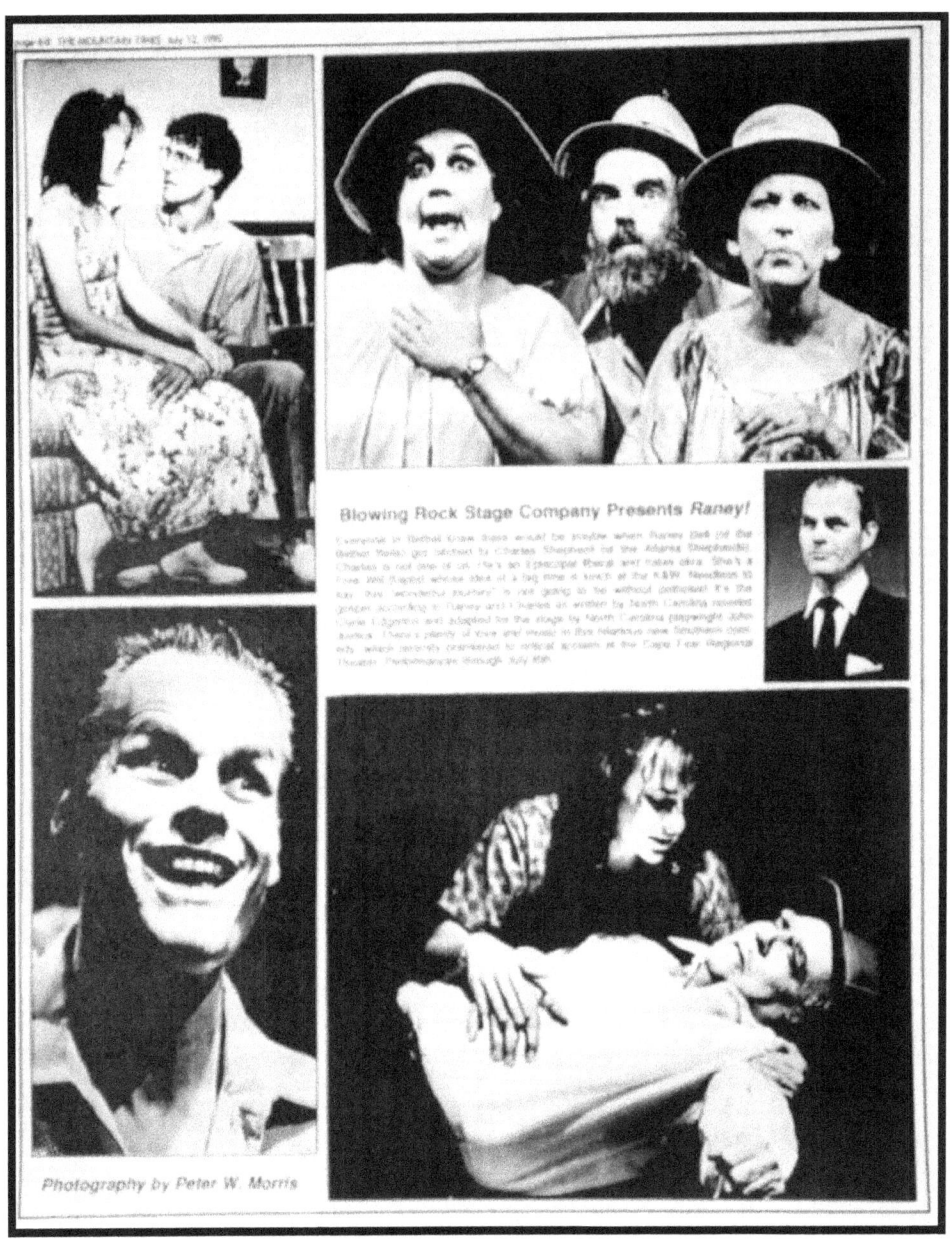

This page was produced to highlight upcoming productions of the Blowing Rock Stage Company. It works, but could have been better.

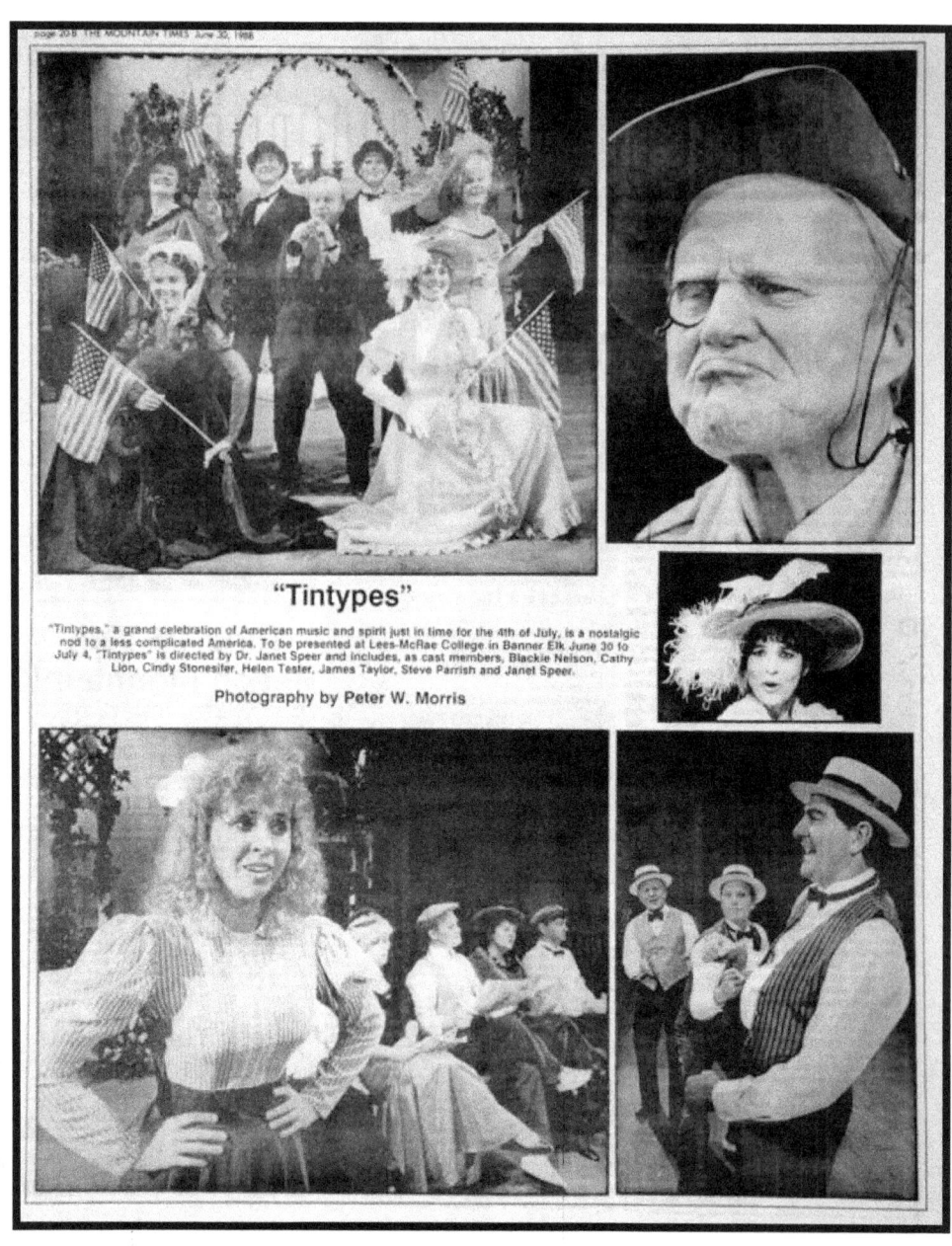

With a character actor playing our beloved "Teddy," you can't miss!

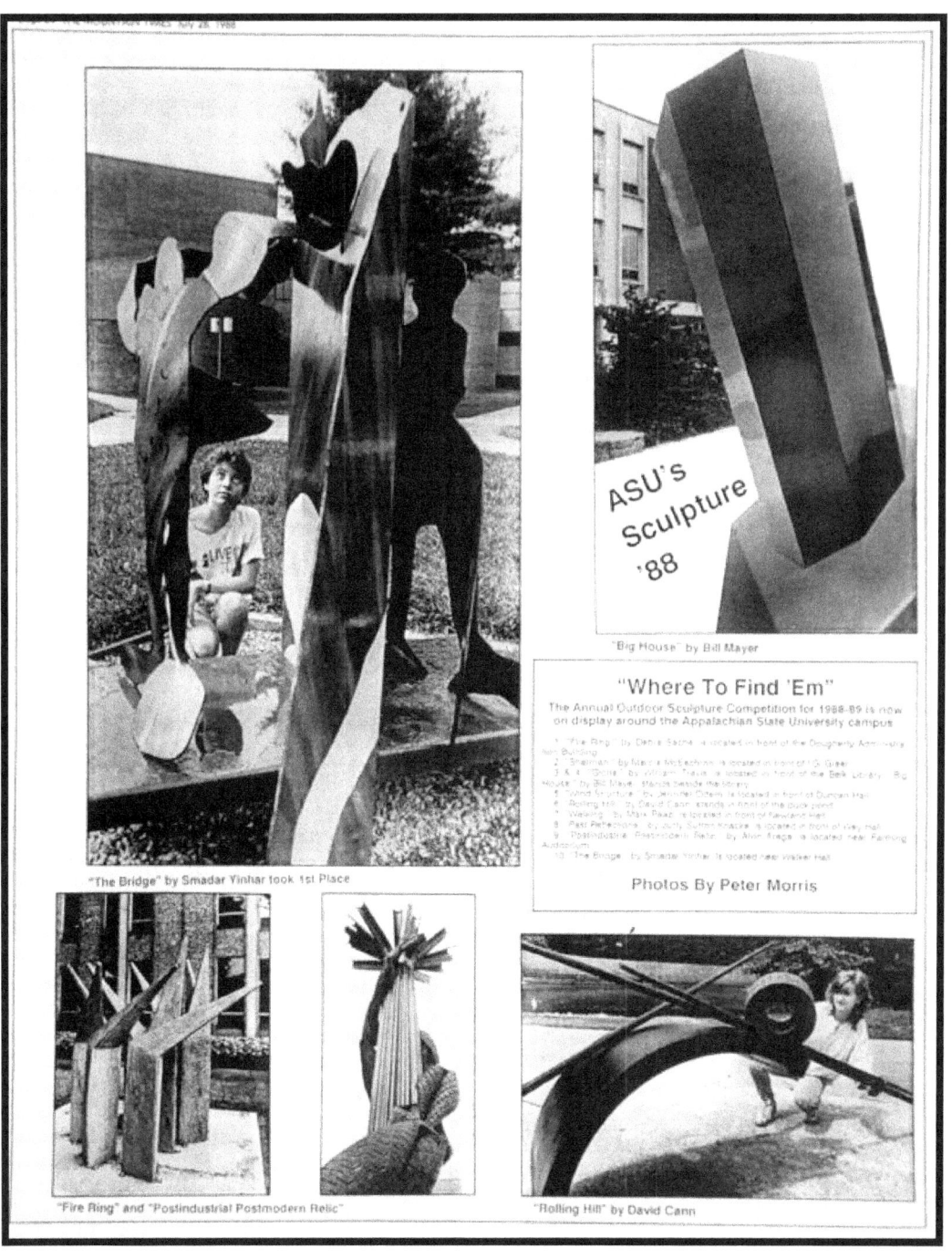

This is art? Oh well, it makes for an interesting picture page.

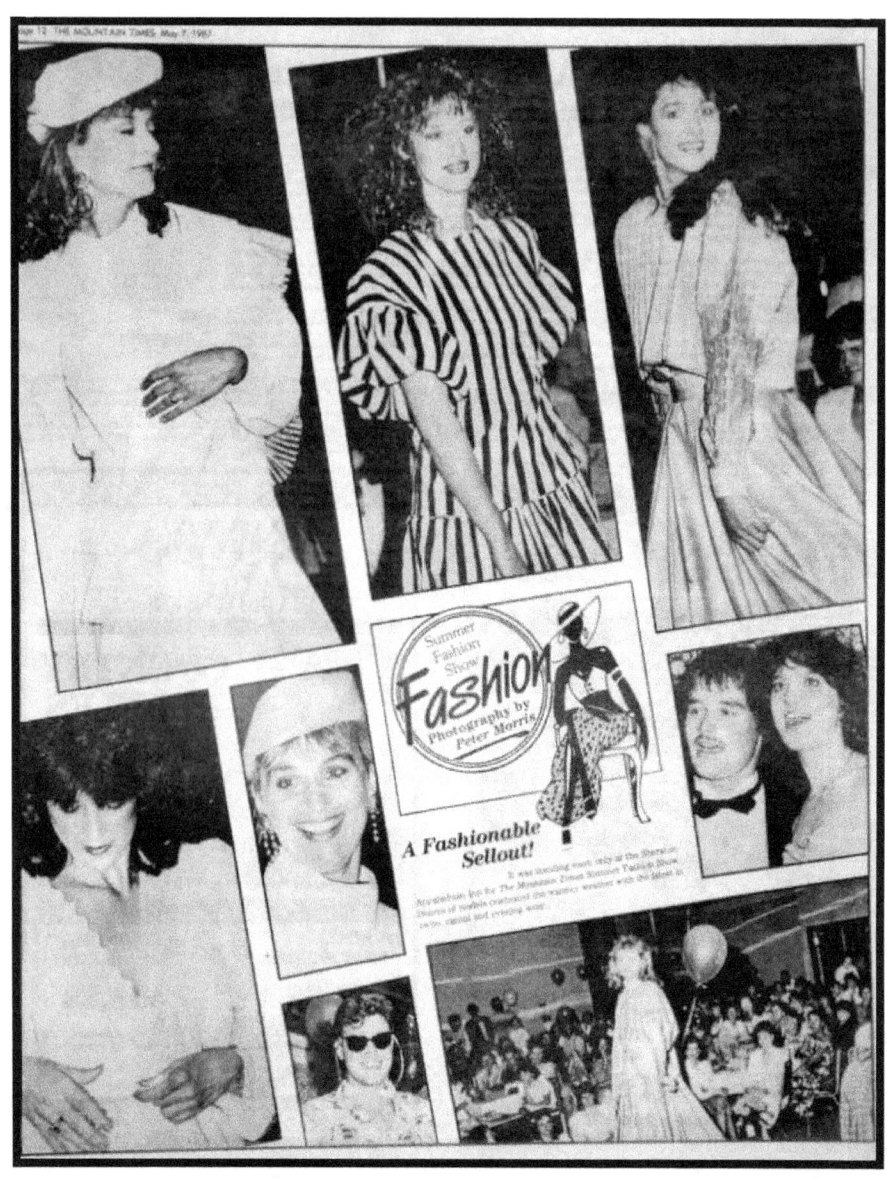

The neat thing about fashion shows is that you can grab a seat, sit back and shoot away.

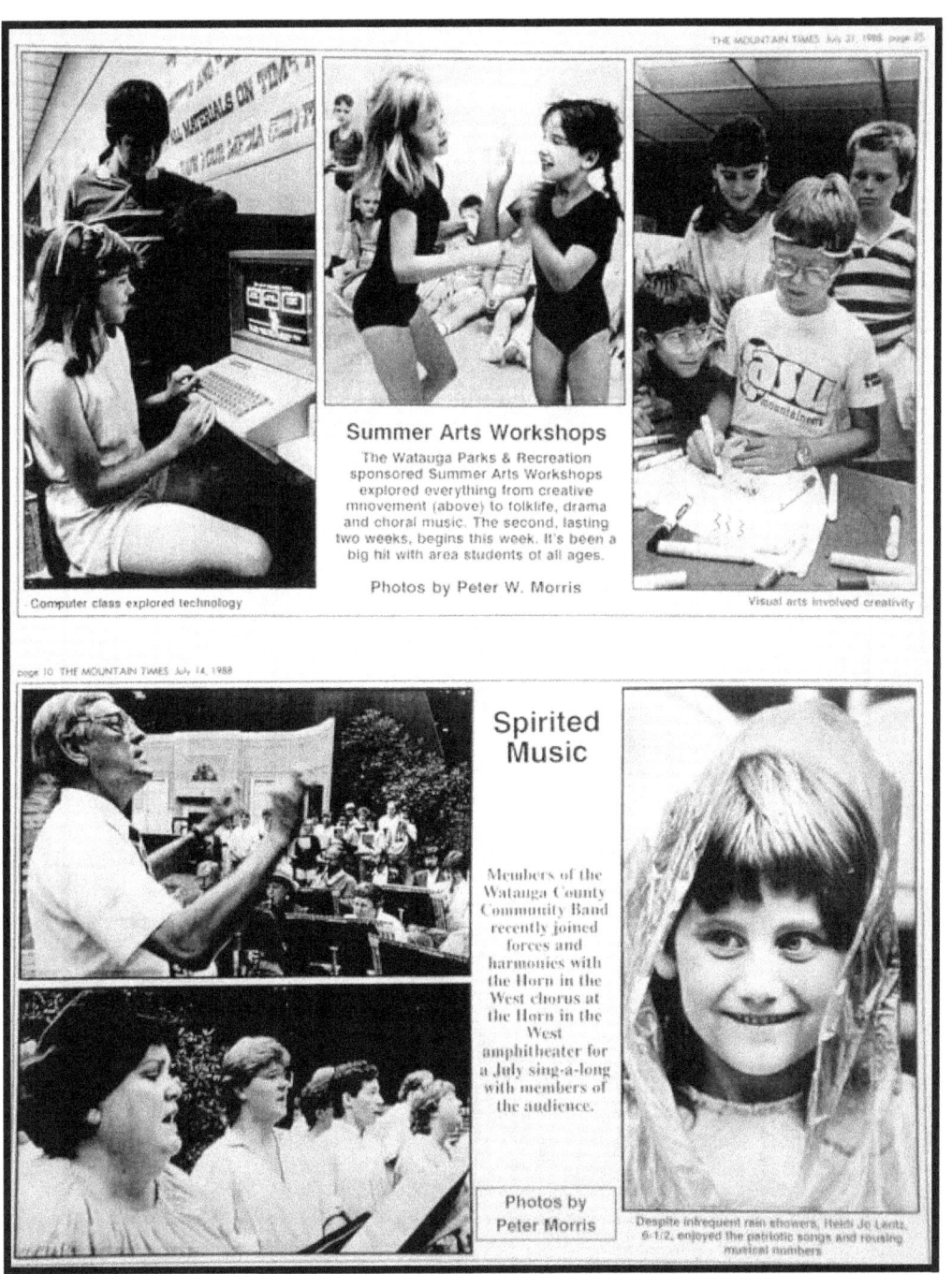

Two pages on one page; it works if the subjects match, as in children.

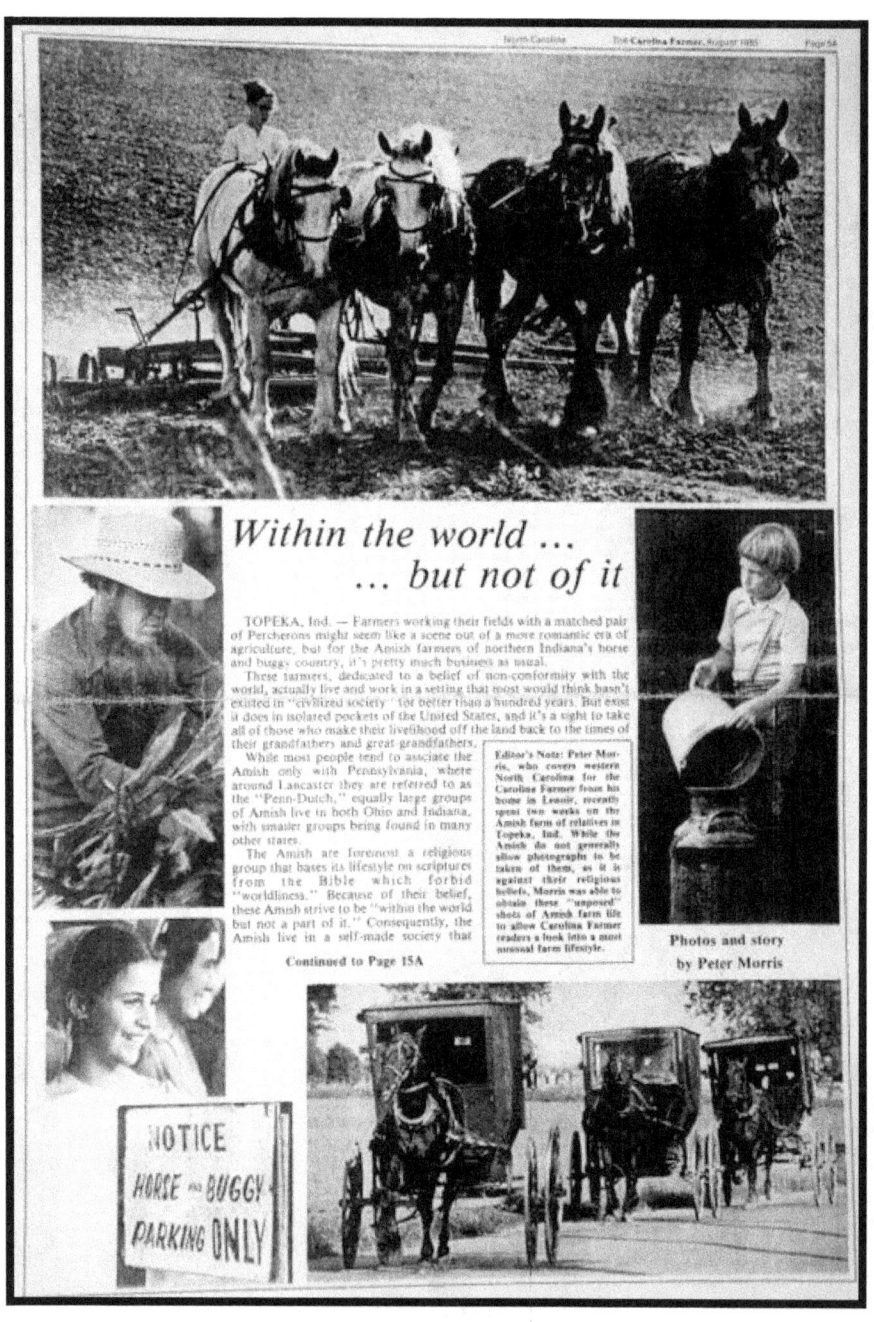

With this picture page, we begin assignments shot for other, daily publications. This page of the Amish of Indiana was transmitted nationwide over the Associated Press.

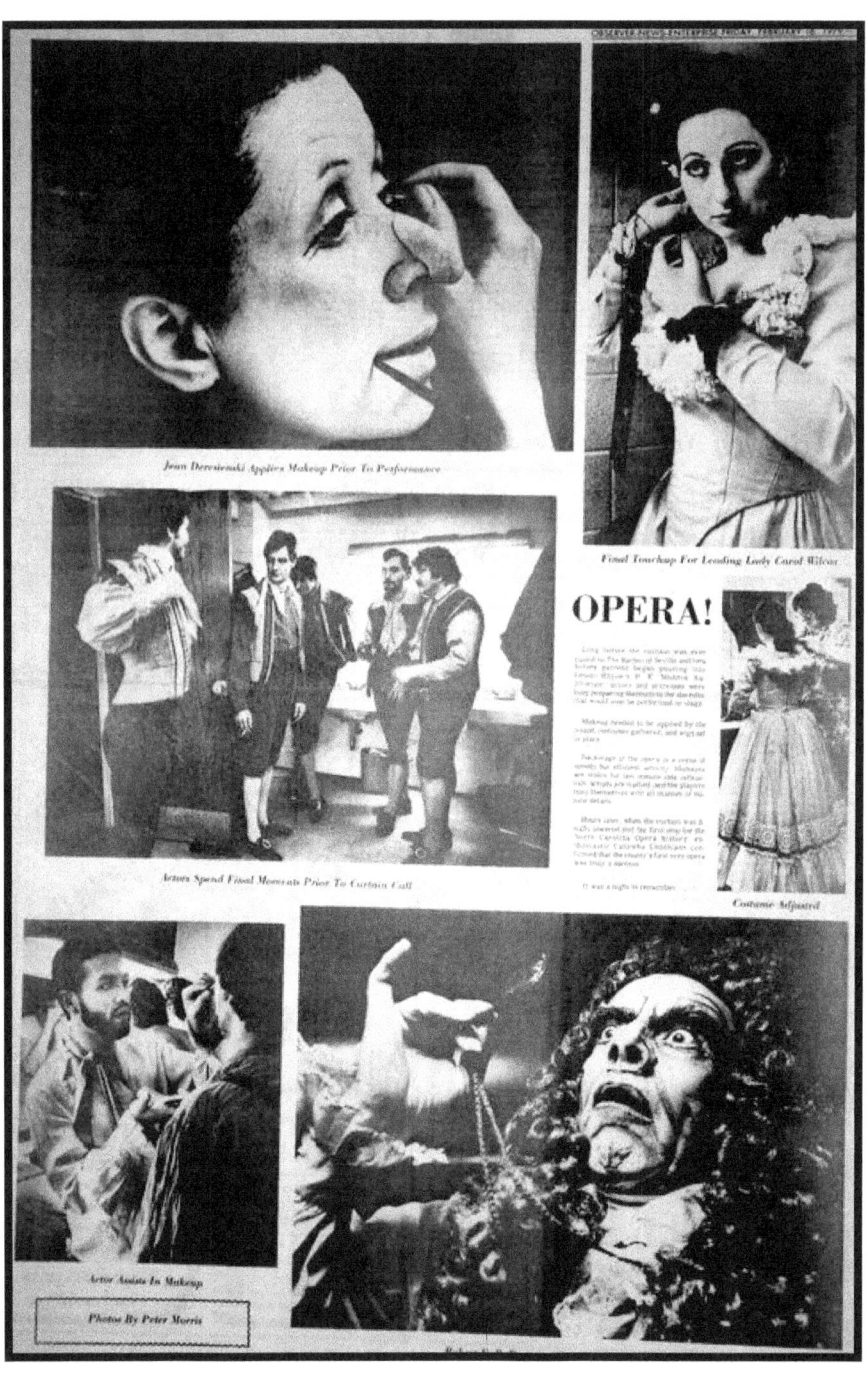

Oh my! Opera! You can't miss with pictures taken backstage.

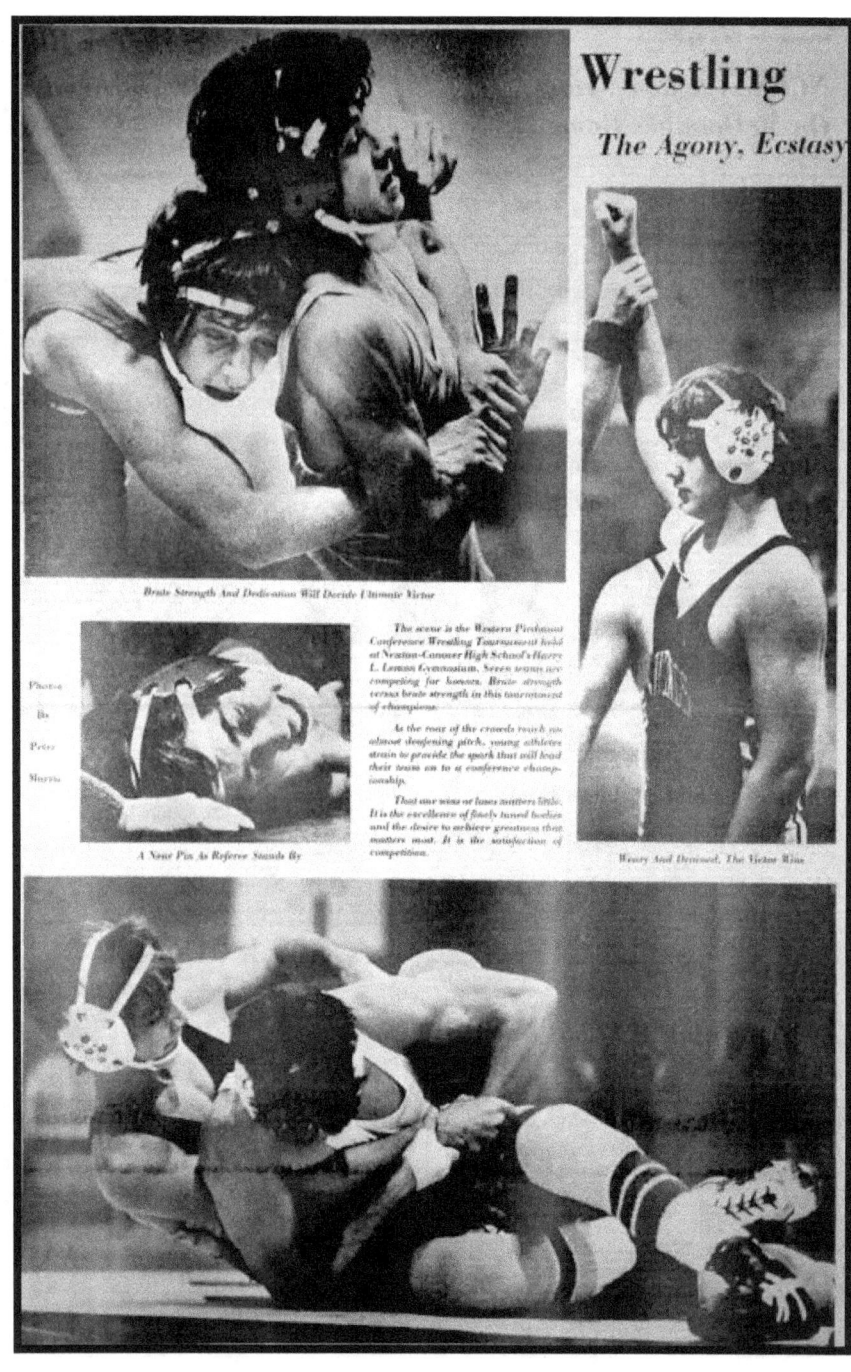

Sports are not my forte, but I did enjoy this high school wrestling match.

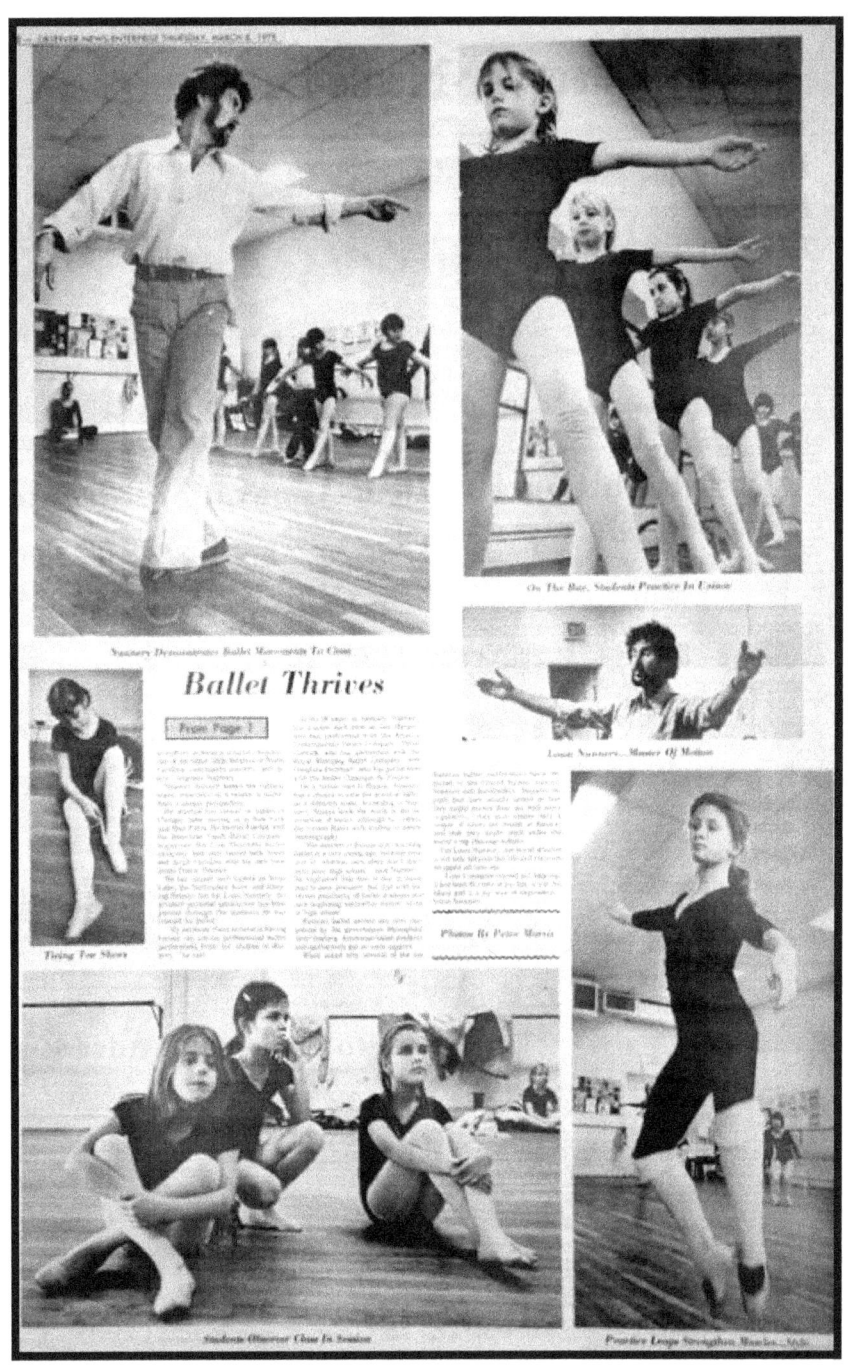

Shooting any of the arts is a pleasure, with dance of all types providing a wealth of images.

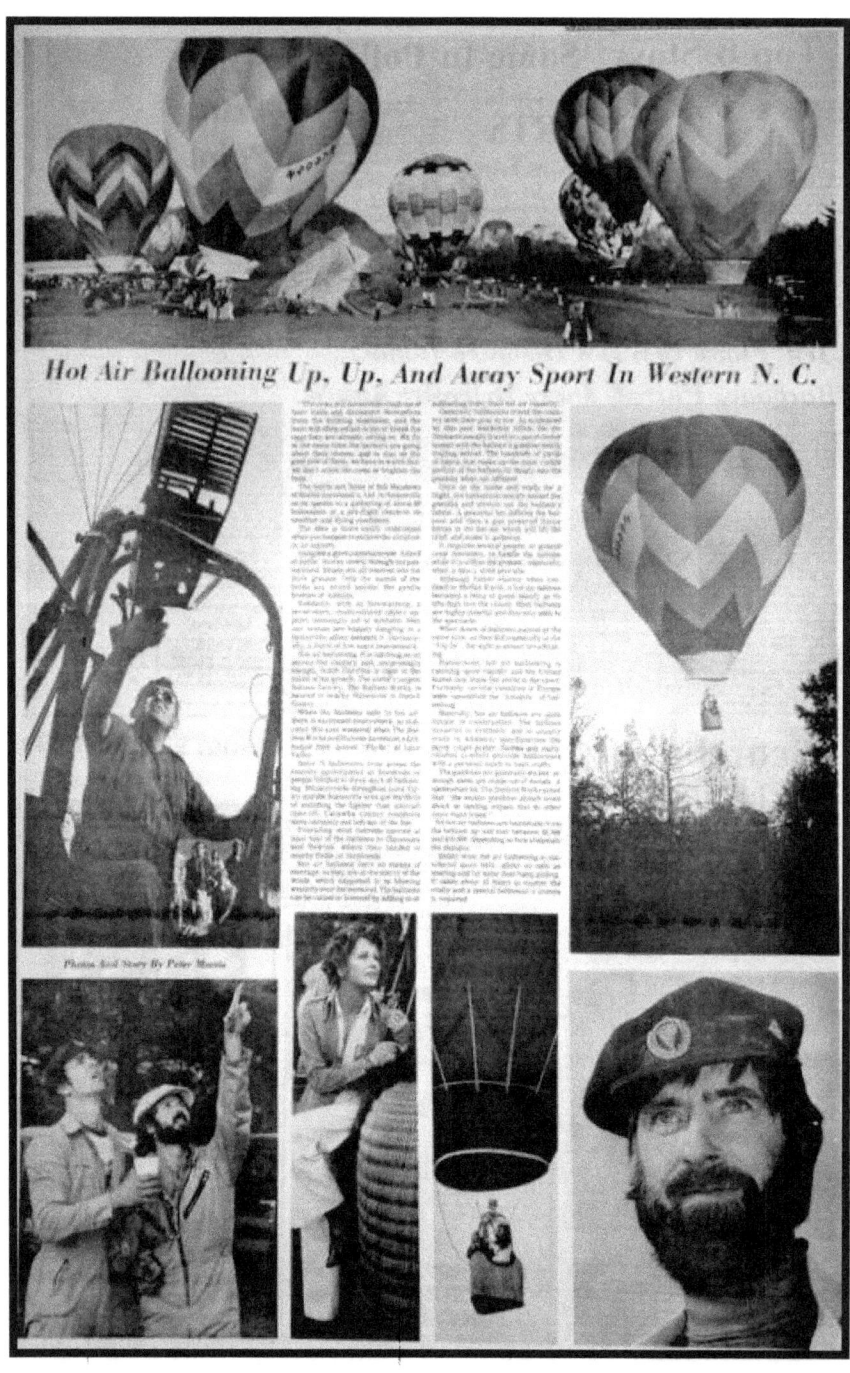

A hot air balloon rally in Statesville, North Carolina.

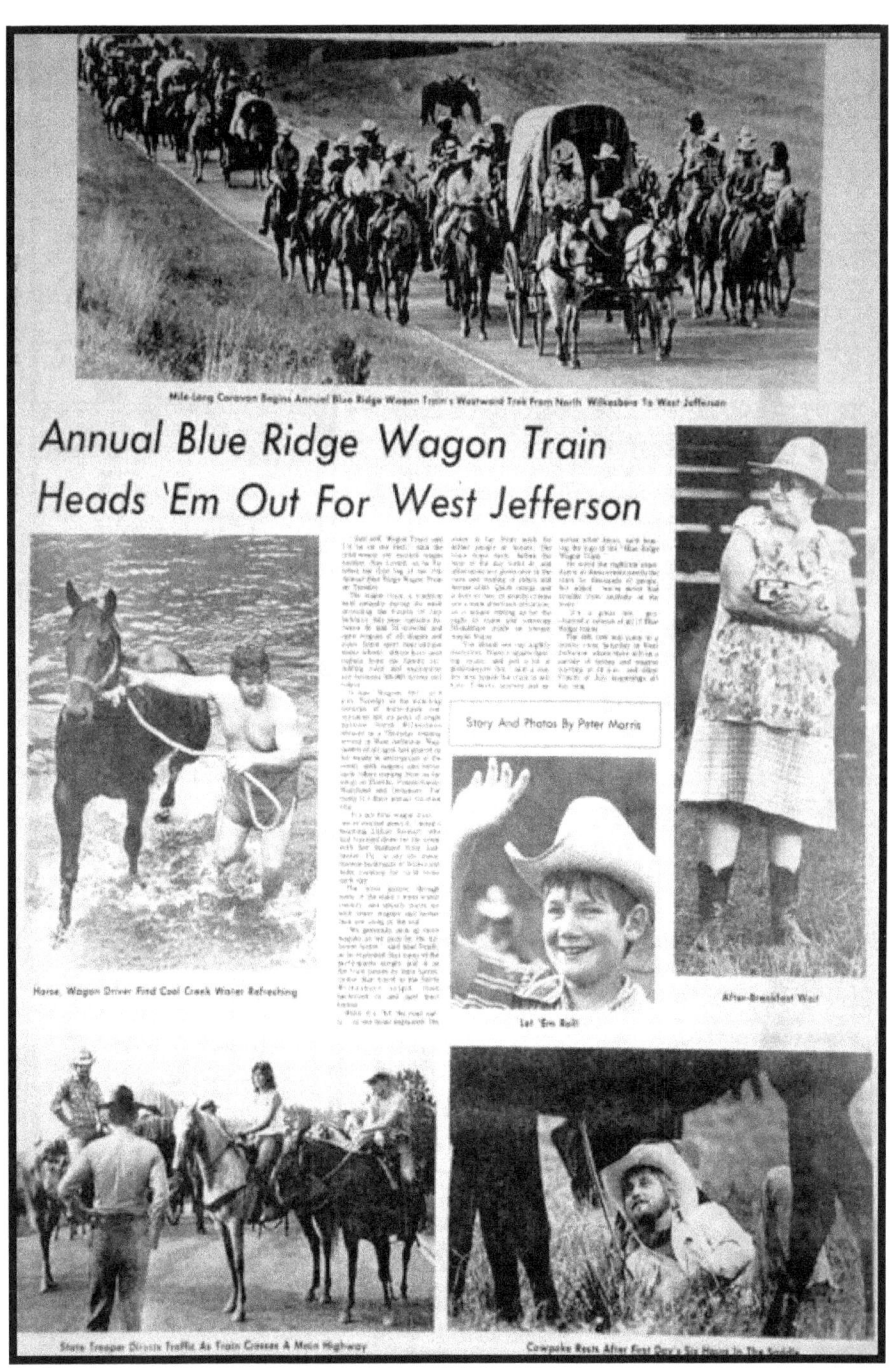

Another wagon train, another year.

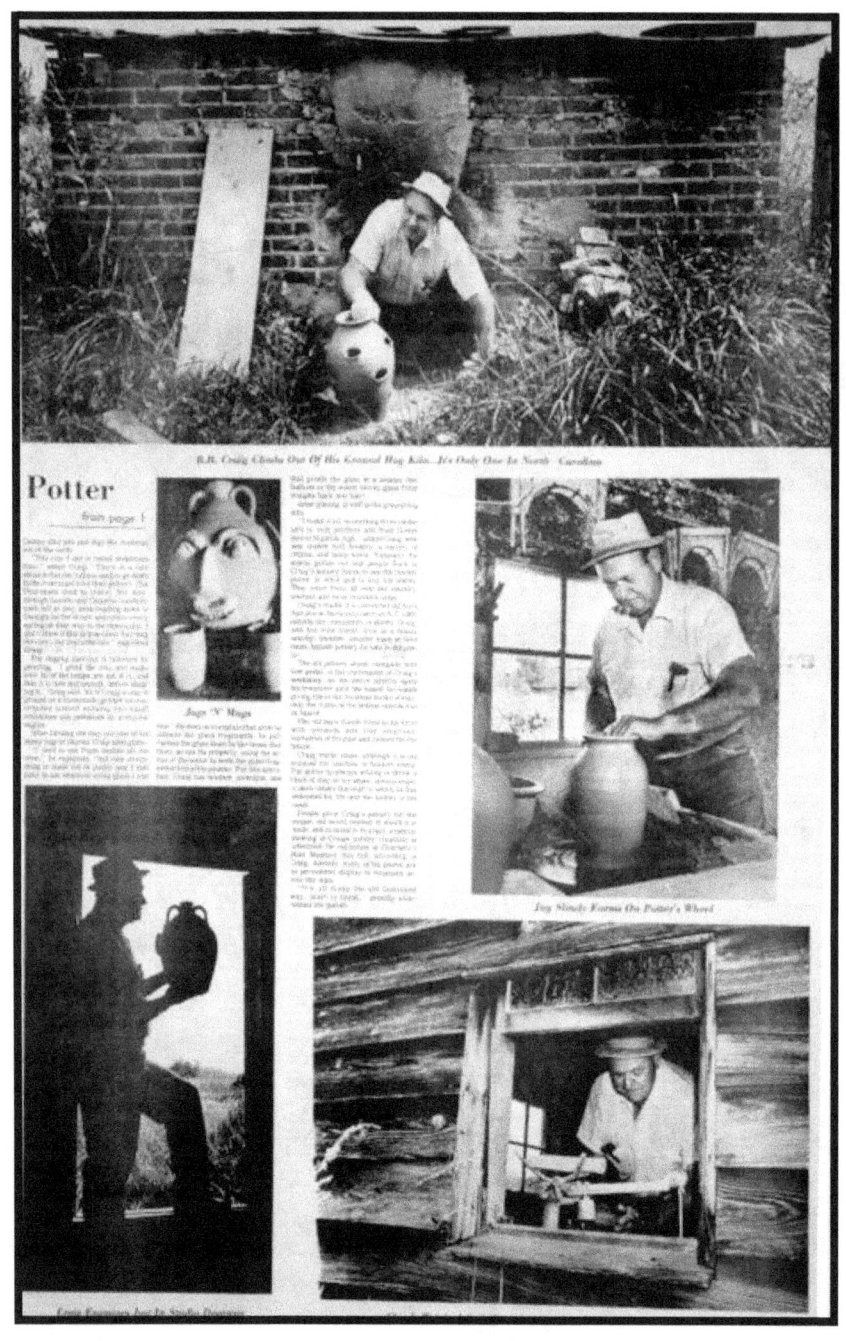

This page followed the work of B.B. Craig, a potter who still used a "ground kiln."

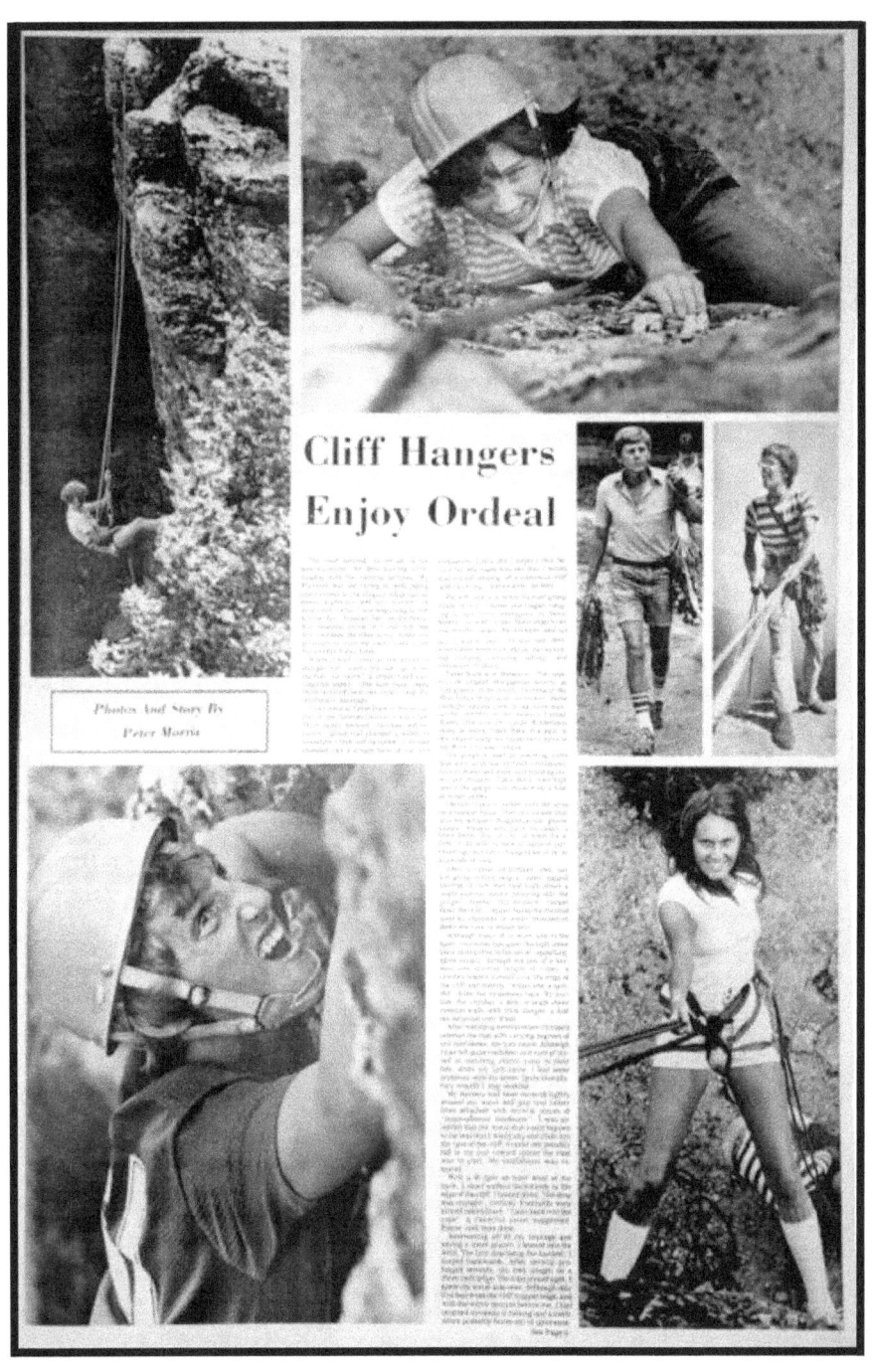

Rock climbing and rappelling...dramatic photos.

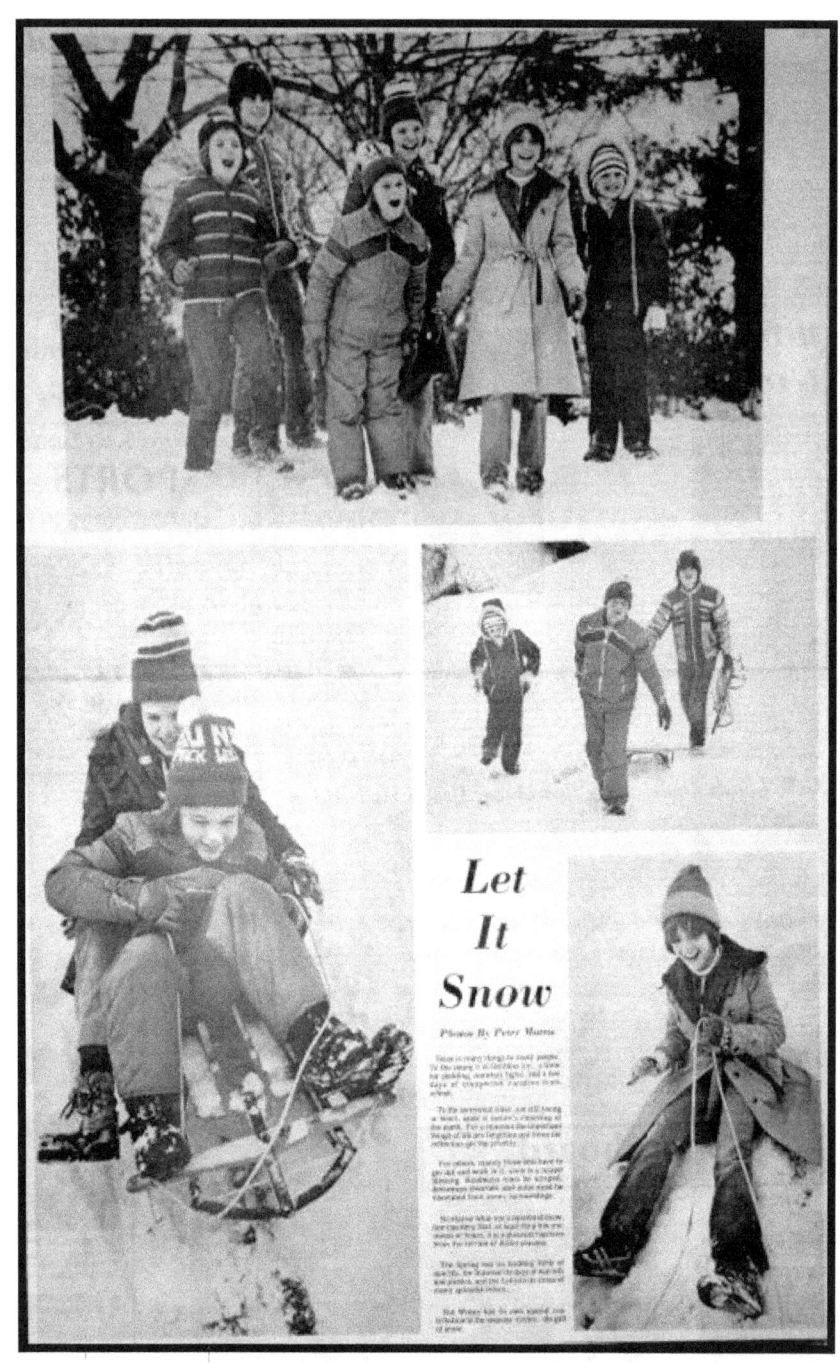

A big hill, fresh-fallen snow.

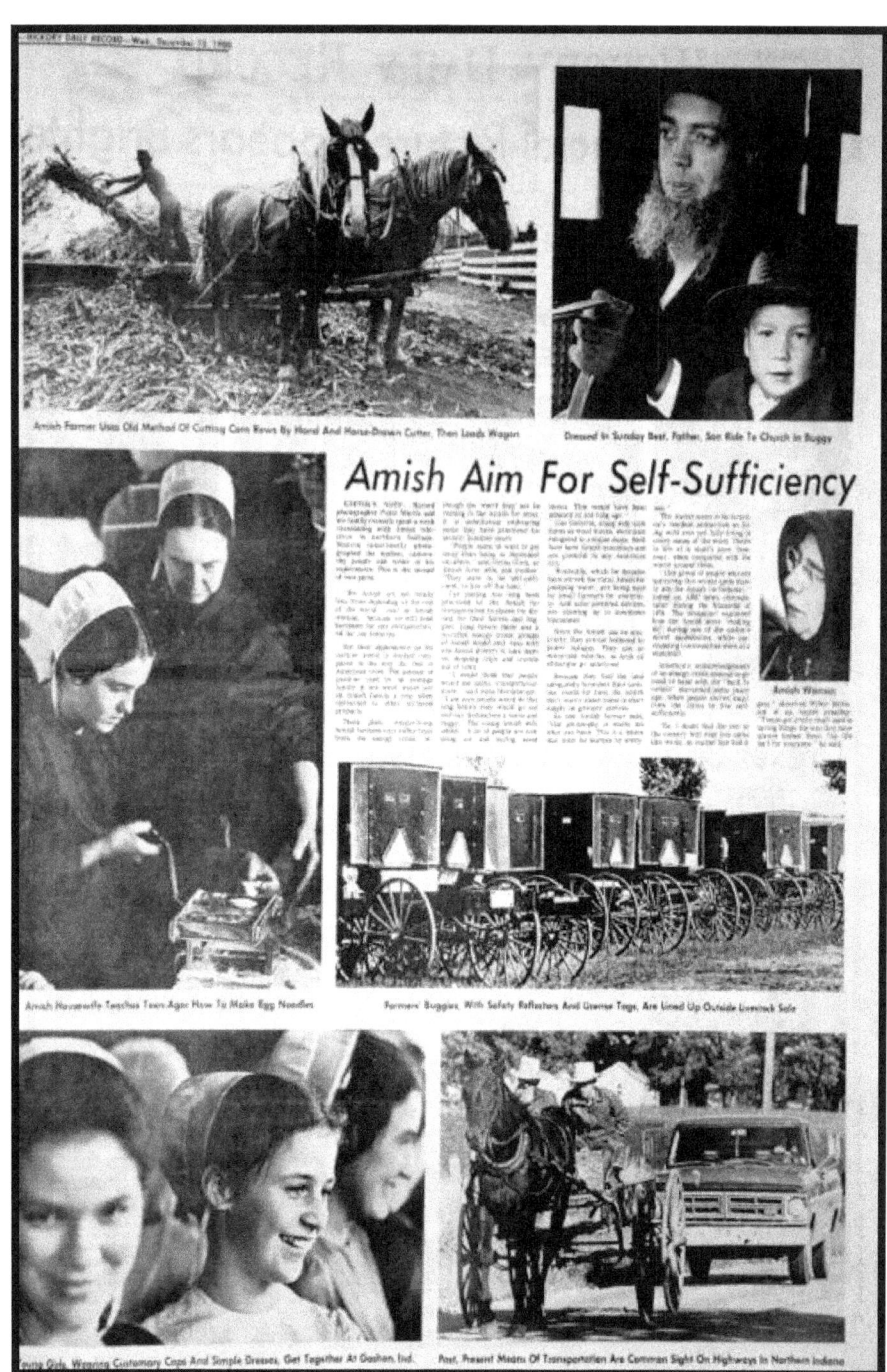

More Amish images, some added from the first shoot.

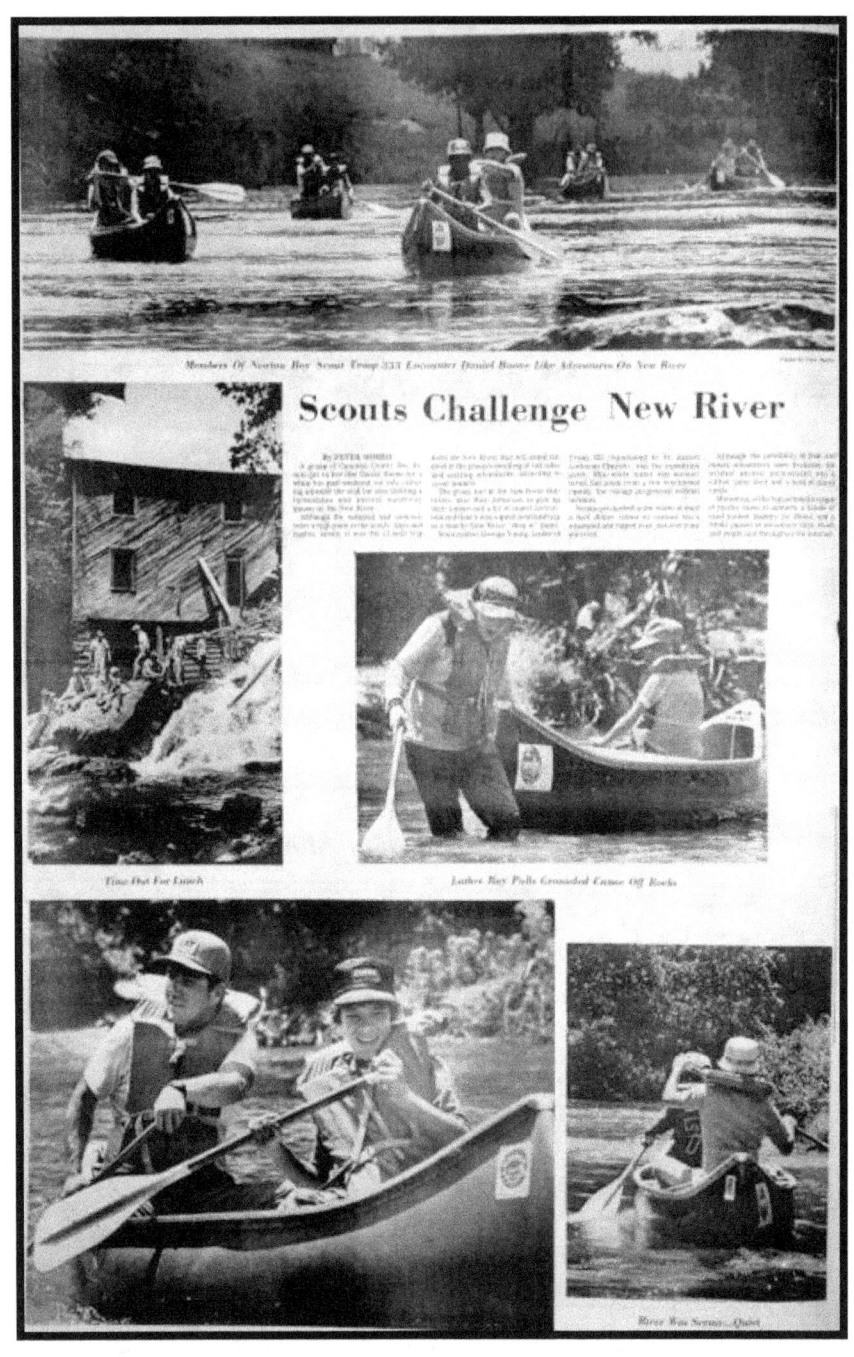

Water sports are always great subjects for photographers.

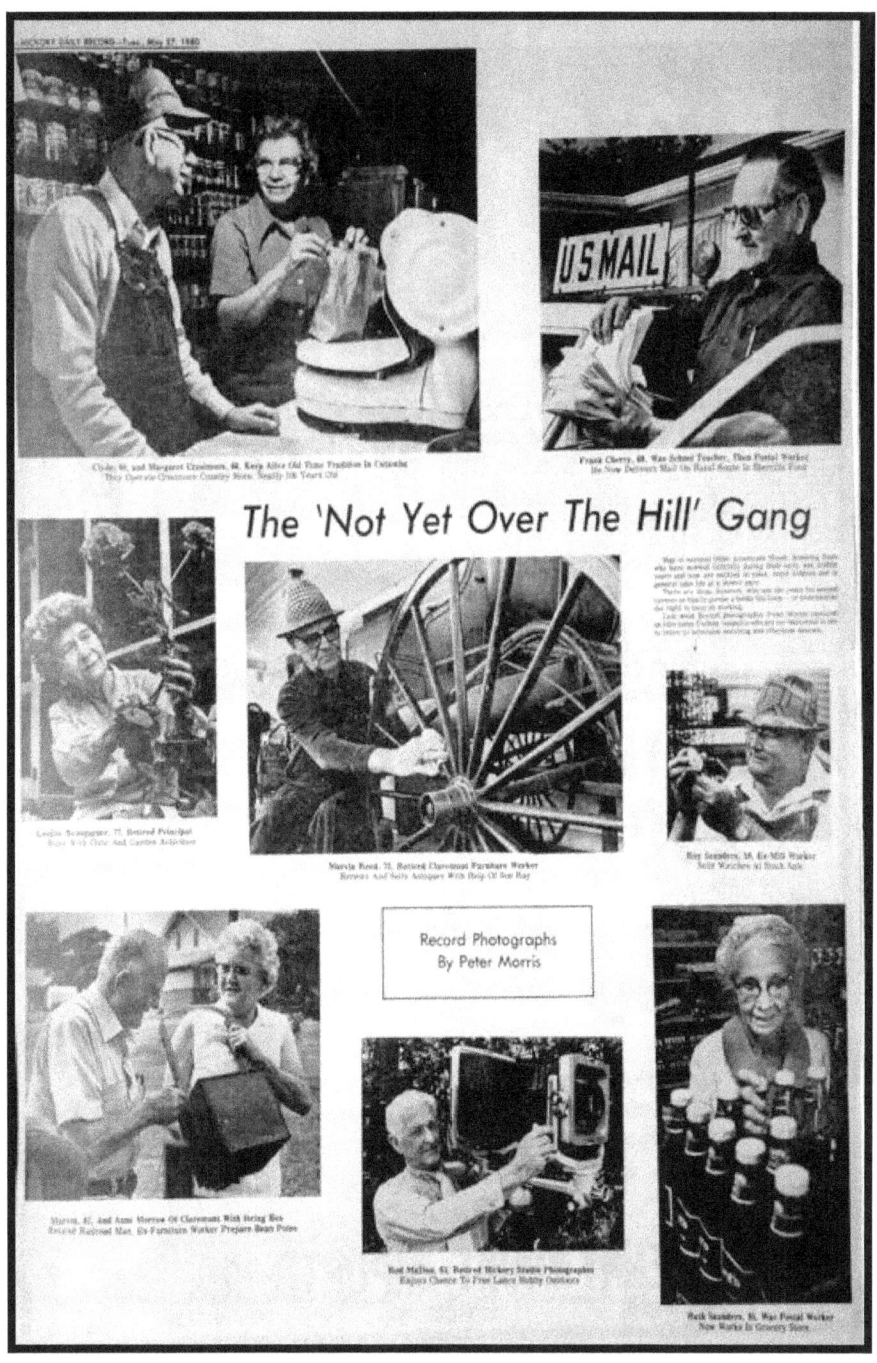

This page was an assignment on "active old people" and required many individual locations and complete "set-ups.".

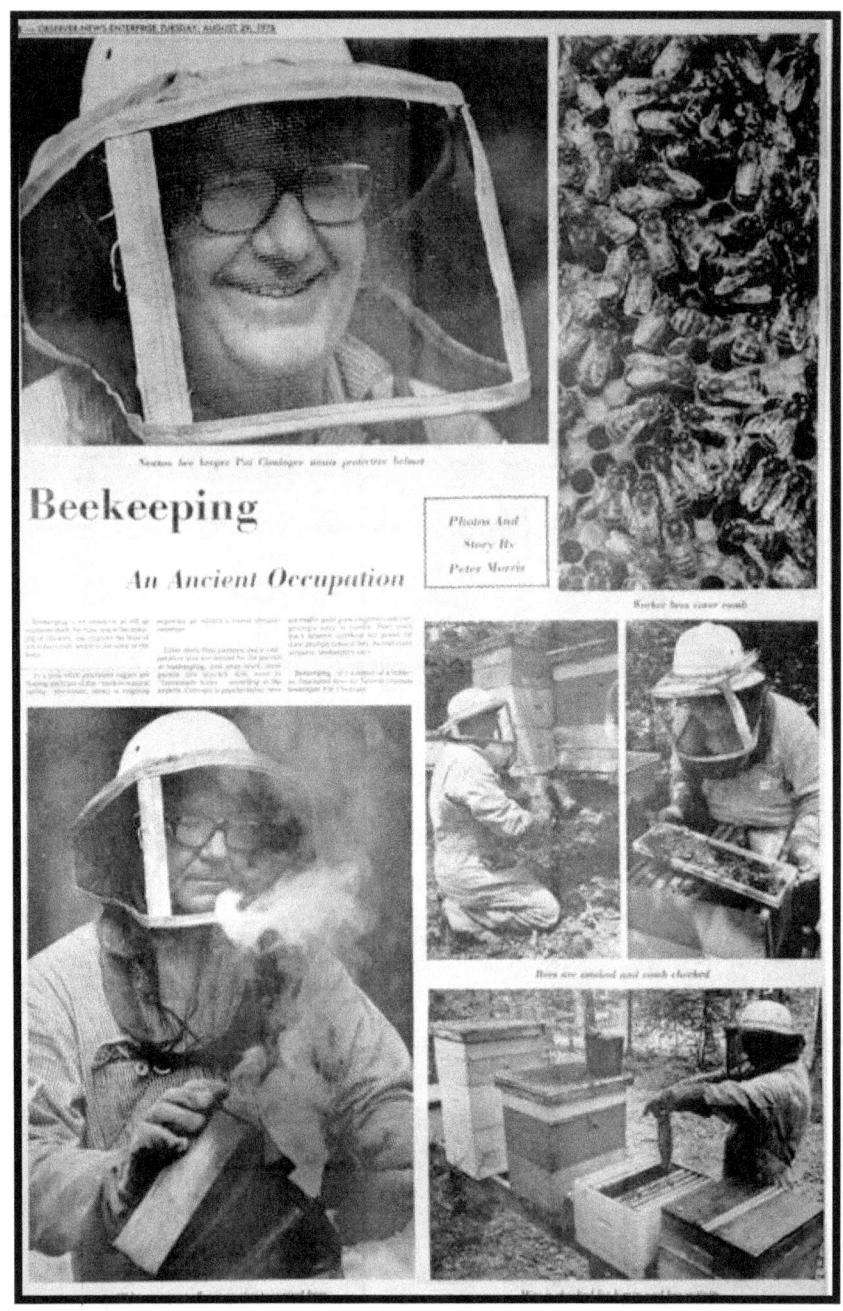

One thing I learned on this shoot, that being to *never* wear hairspray or cologne when shooting bees; I received numerous stings.

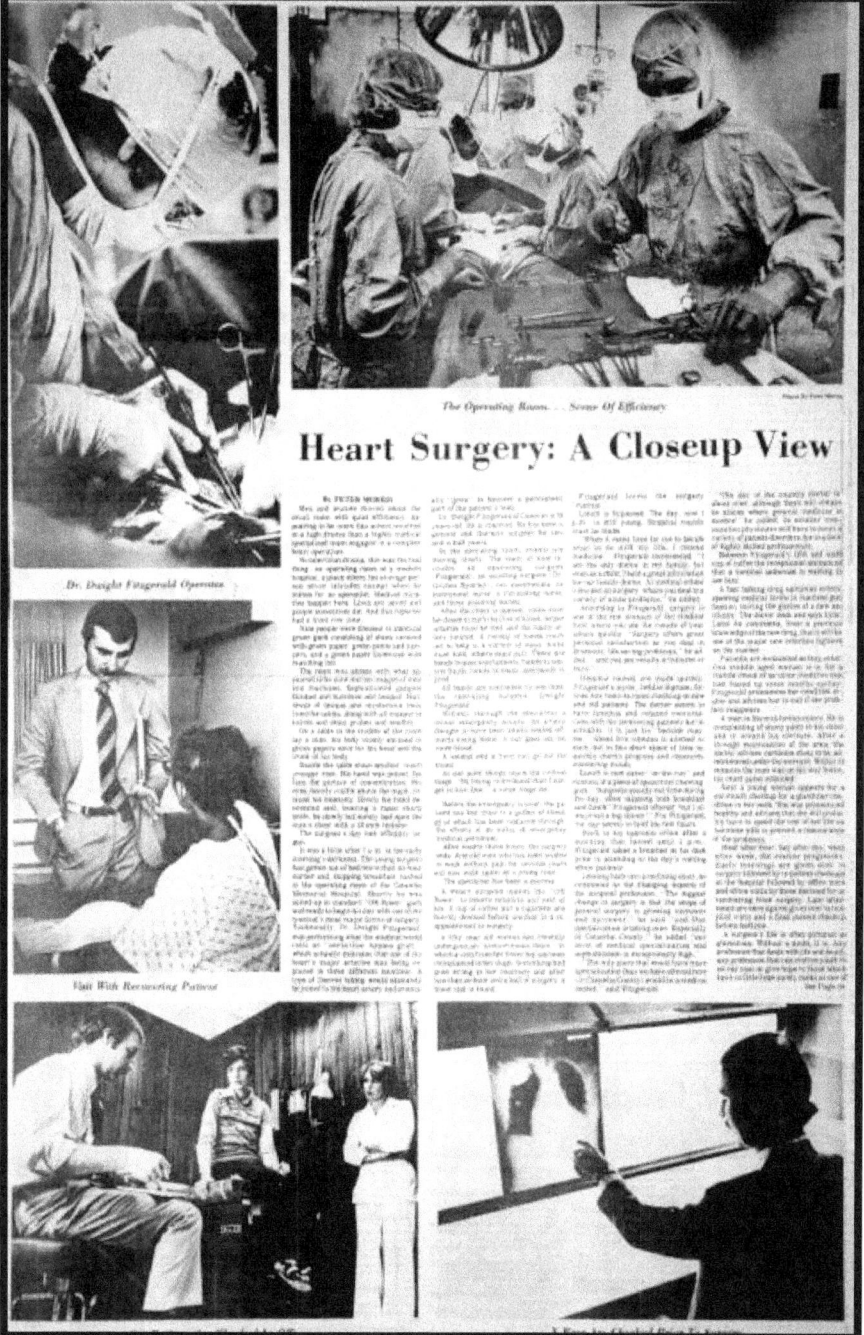

Many are the surgeries I've photographed; the process never gets old.

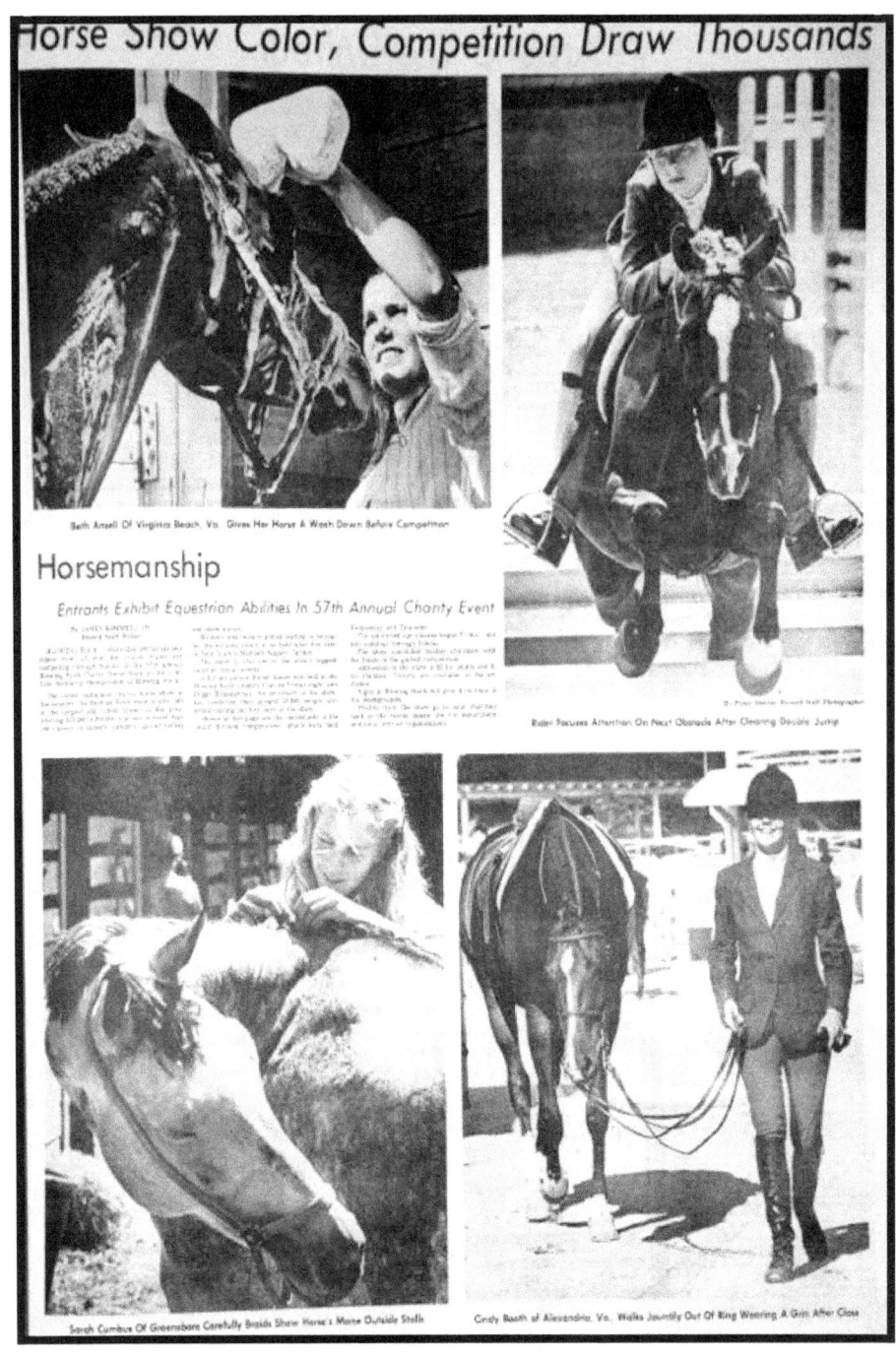

I especially recommend the shot upper right, a most unusual take on a jumper...head-on.

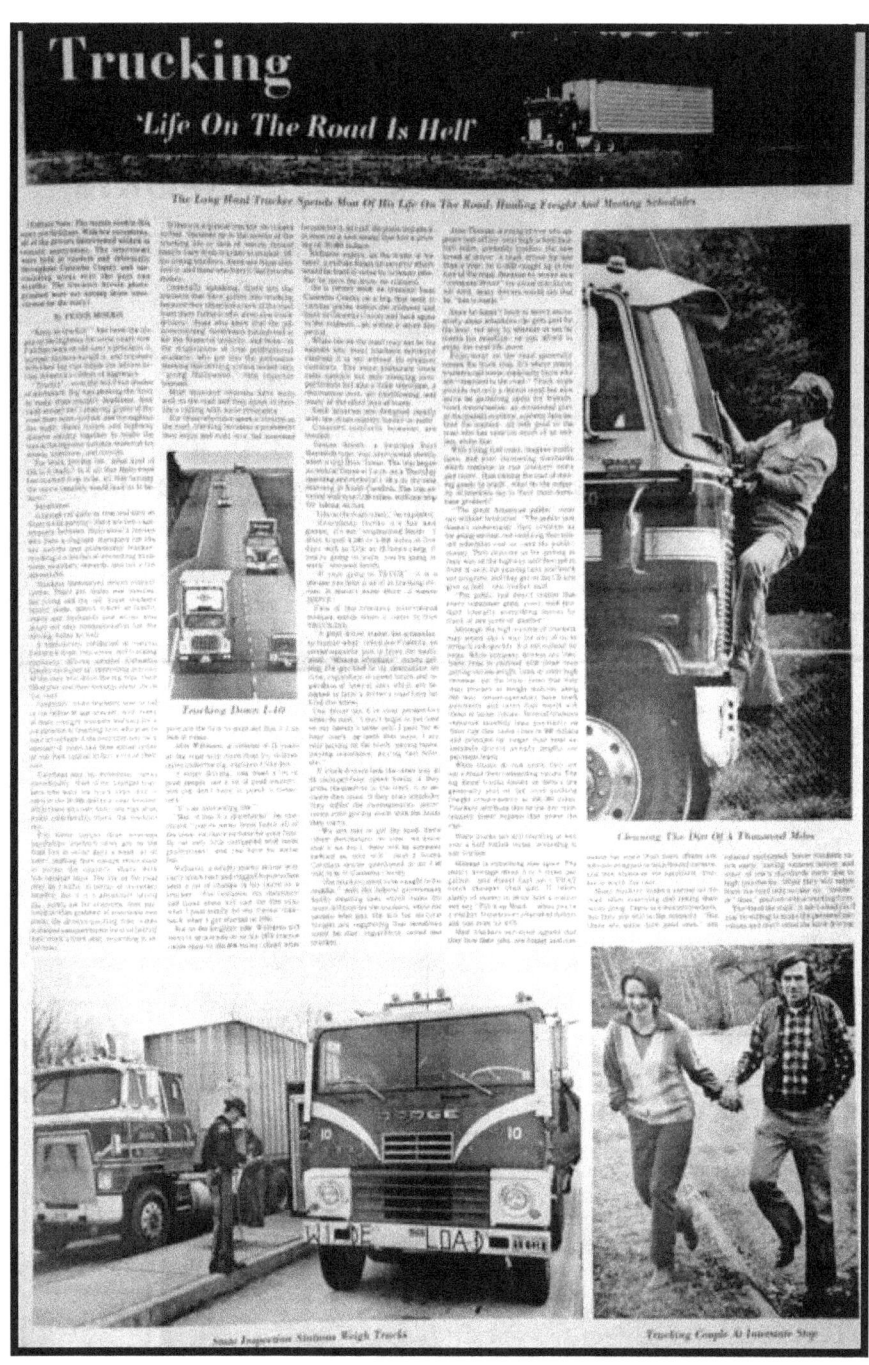

A somewhat unusual subject, shot at a truck stop on Interstate 40.

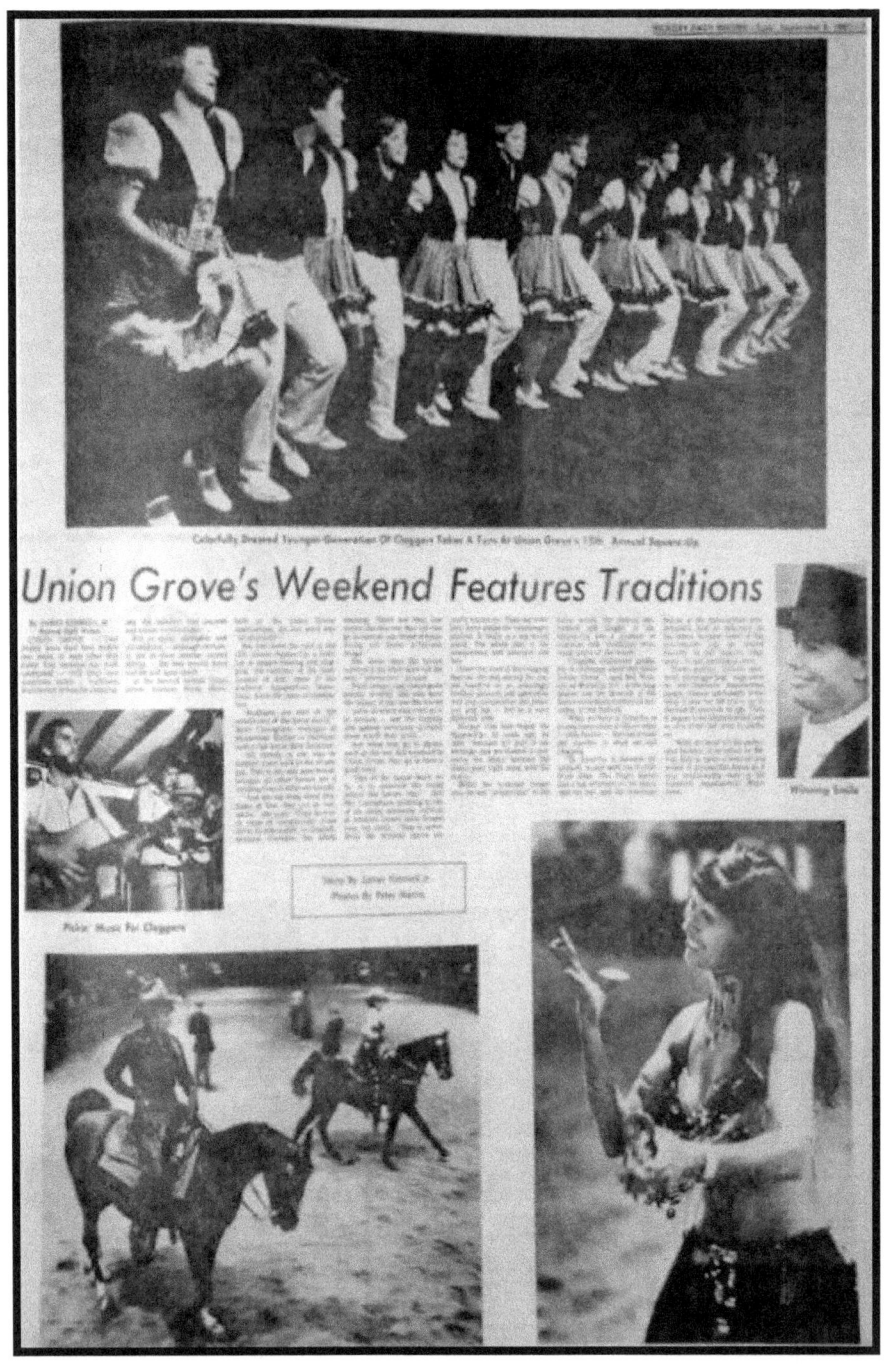

I don't even recall this assignment, but I do like the way it turned out.

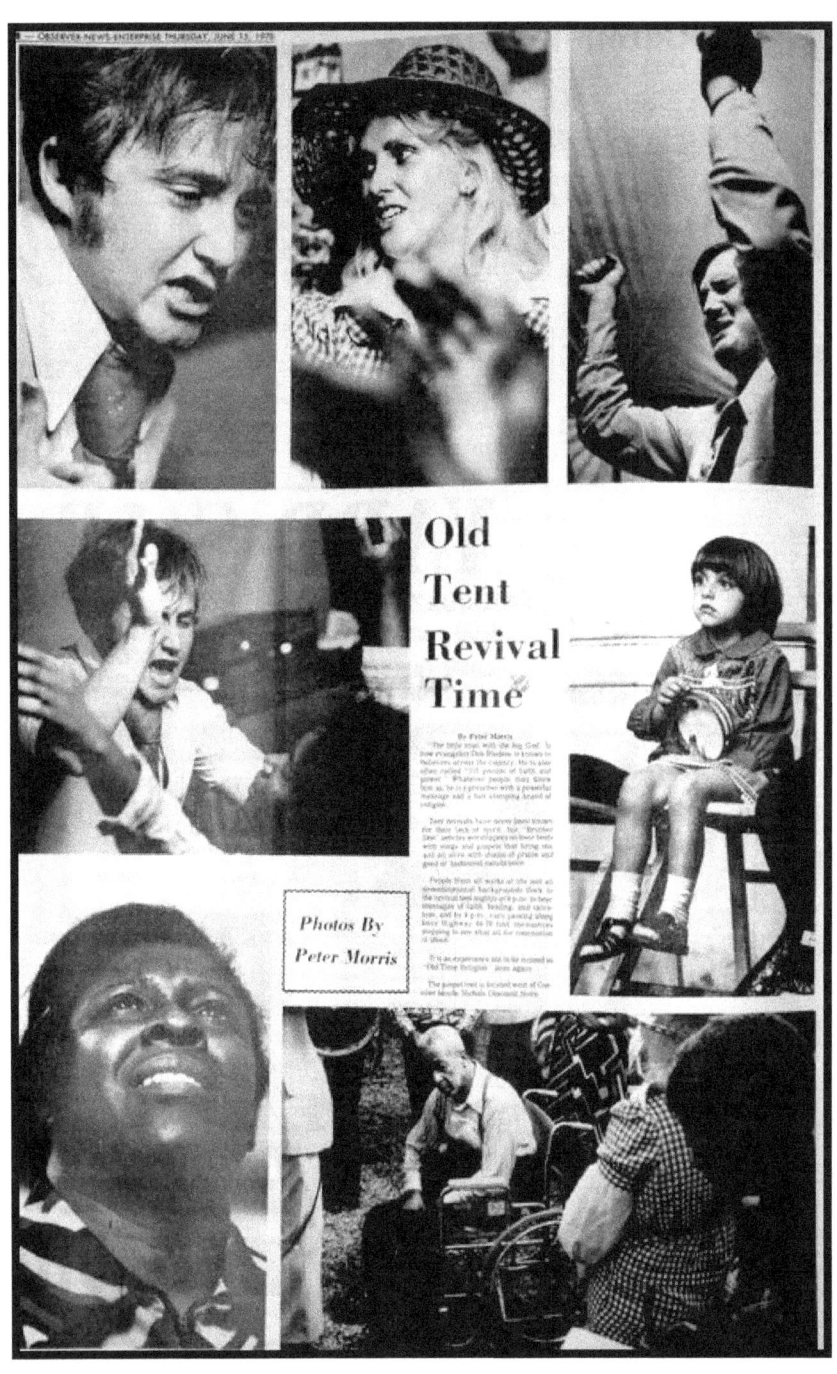

He called himself "the little man with the big God."

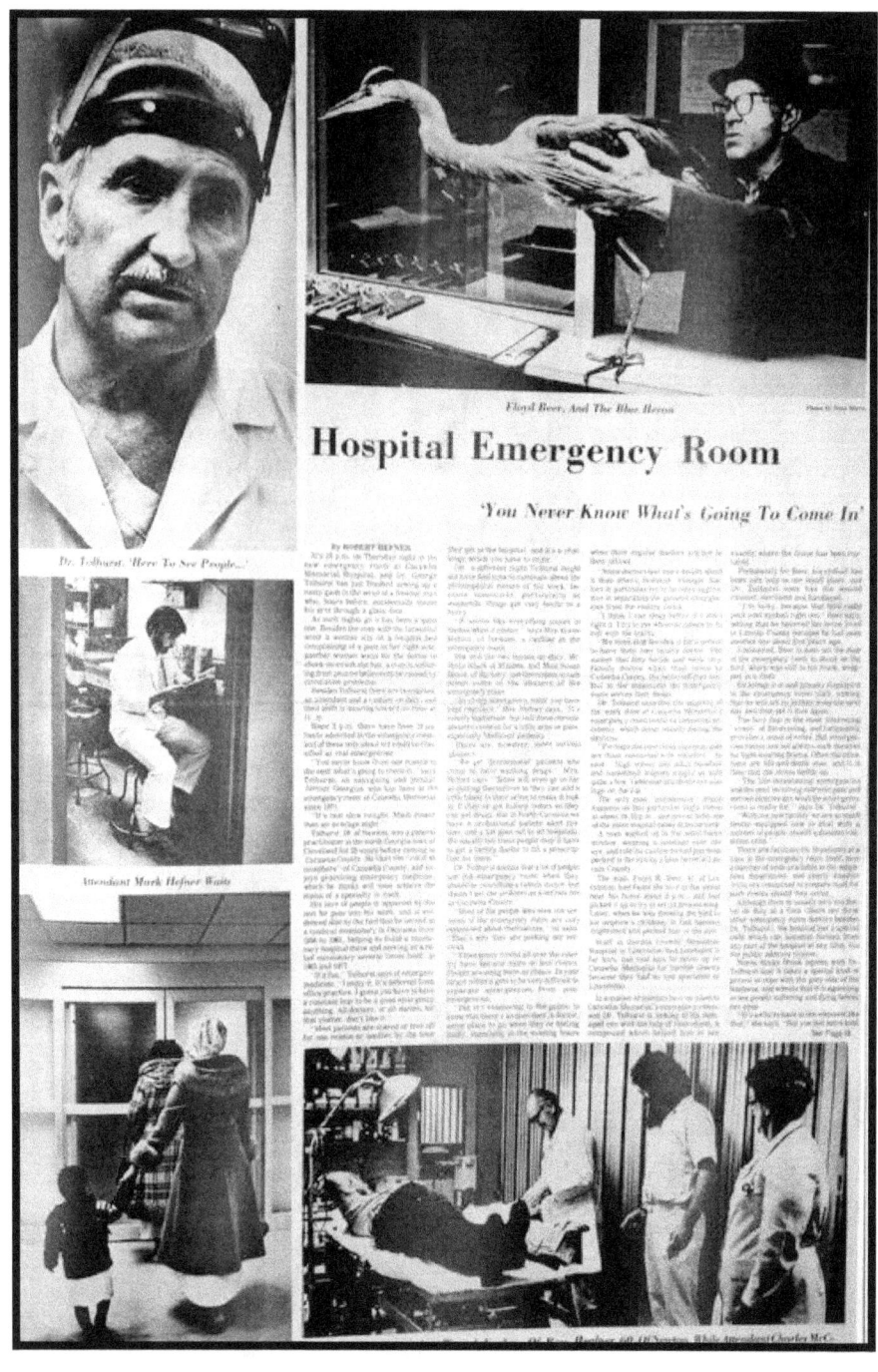

This unusual shot was among the crazy happenings at a hospital emergency room. I stayed the night, which was otherwise uneventful.

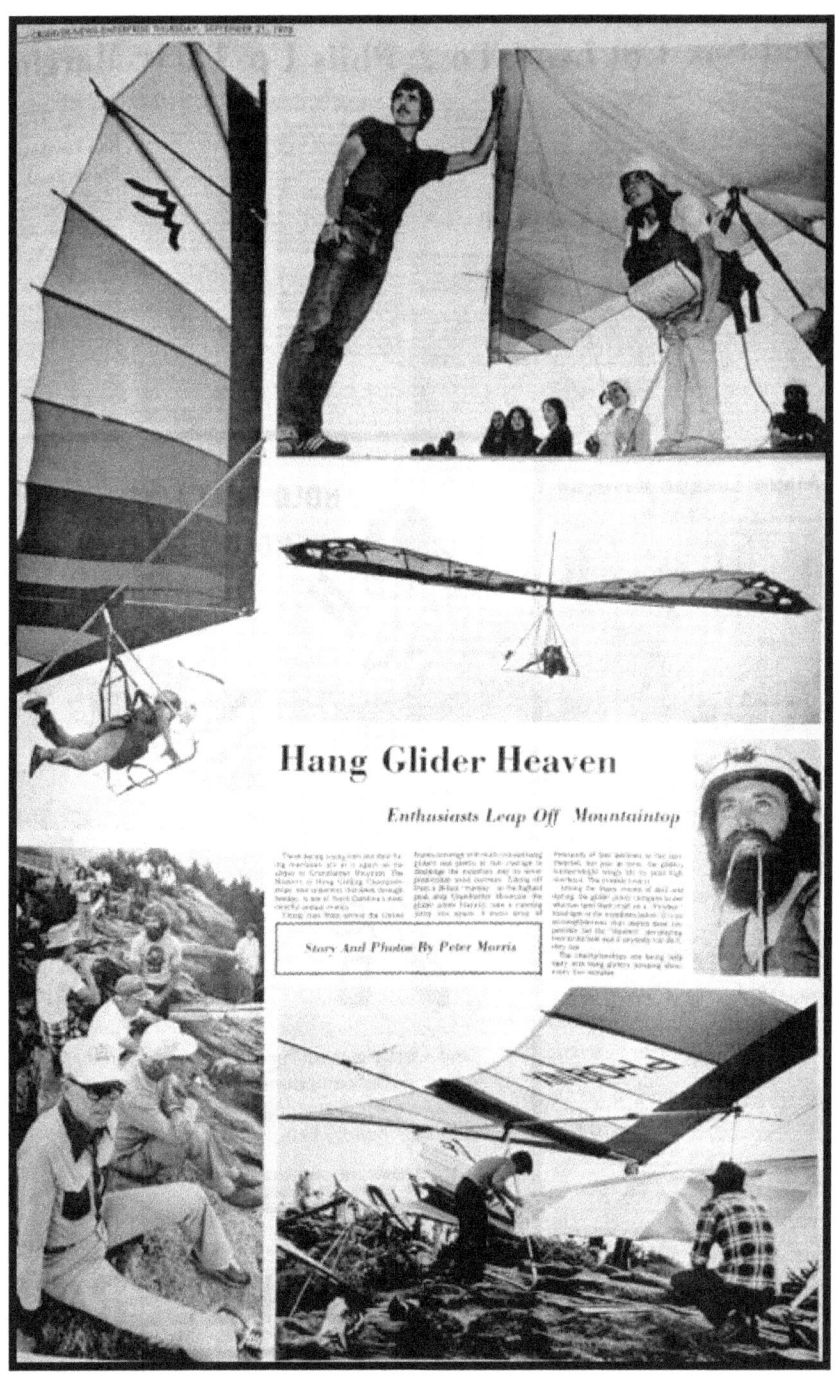

Hang gliding competition offers exceptional images.

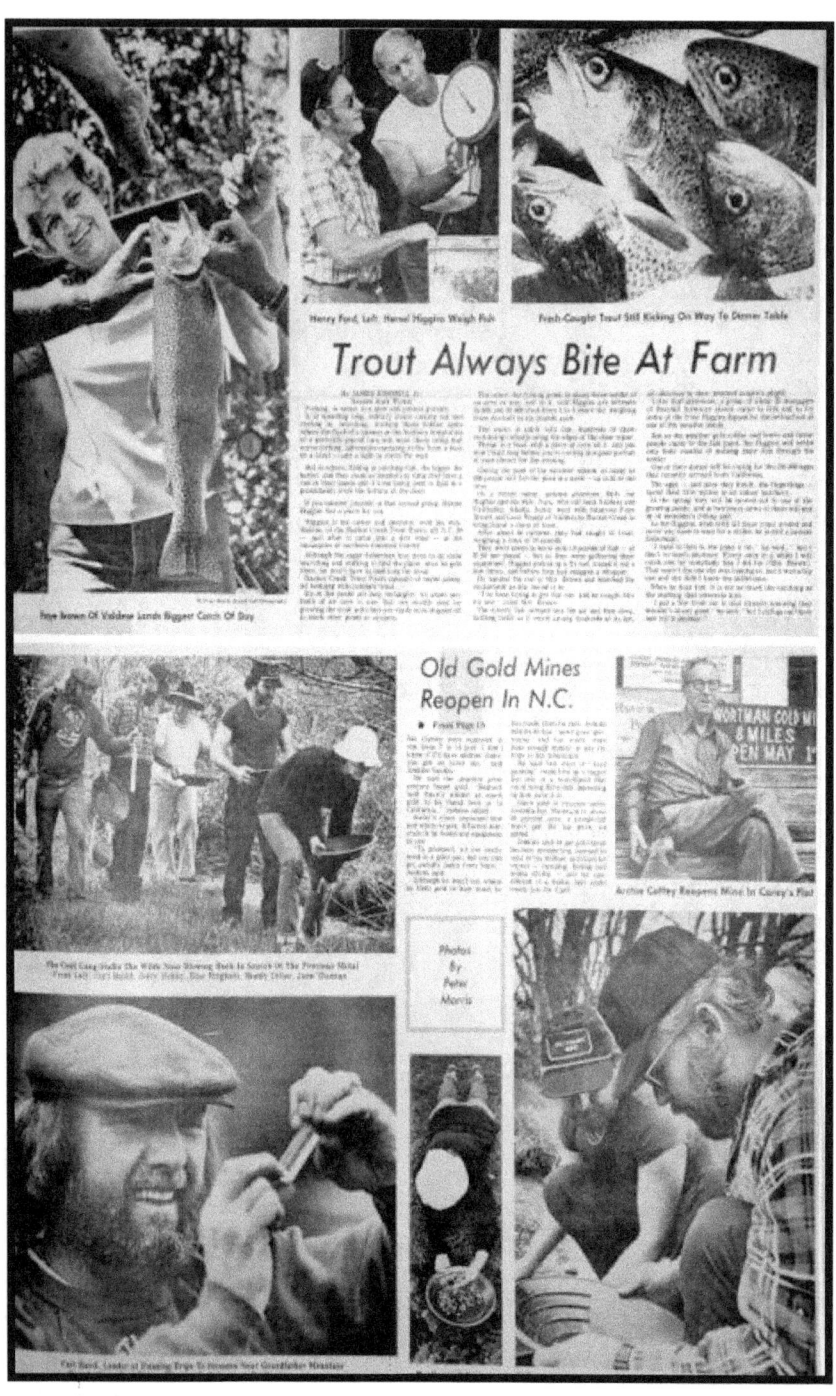

Easy fishing, easy pictures at a trout farm.

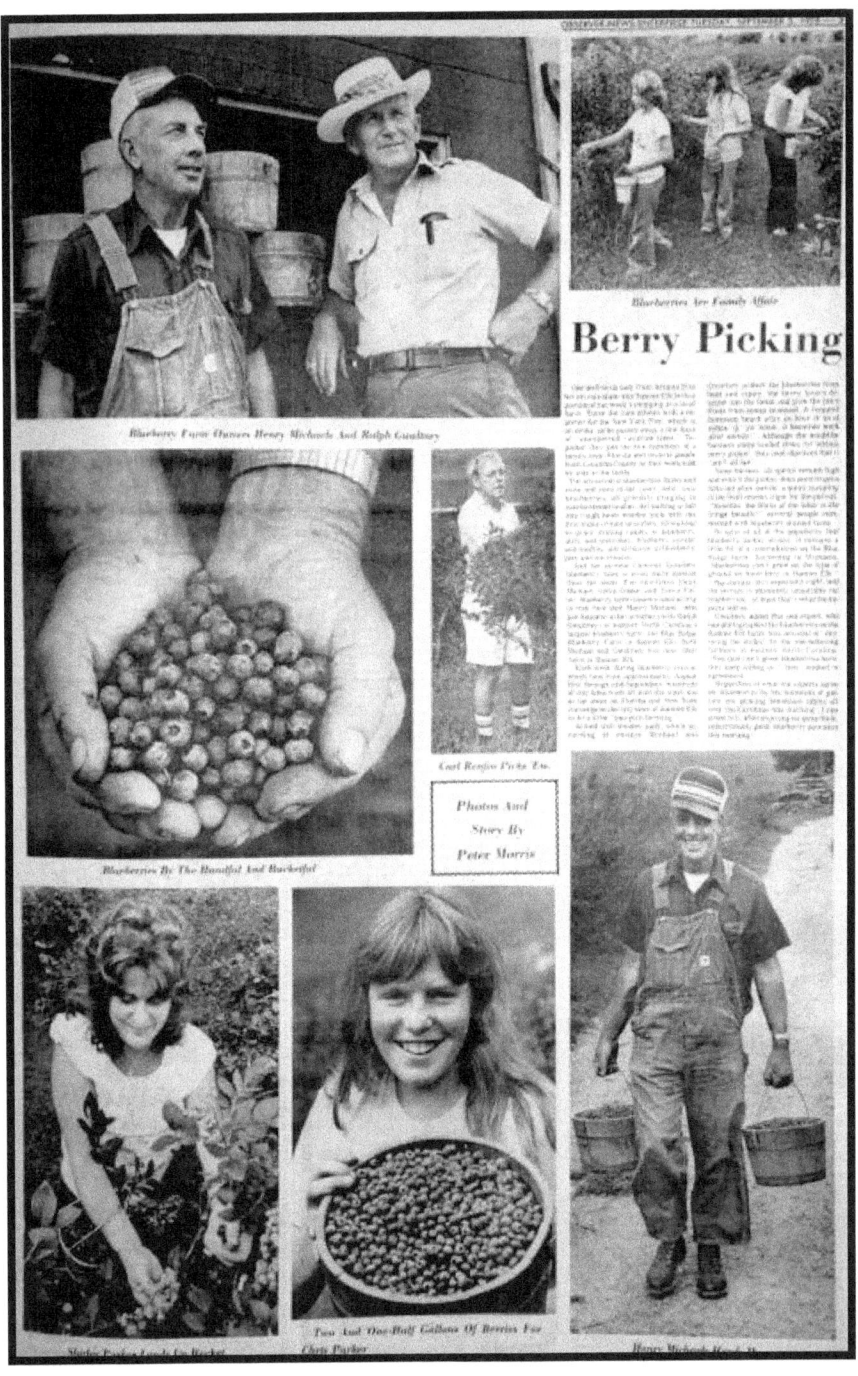

When I moved from the mountains from Florida, I discovered blueberries and a new photo source.

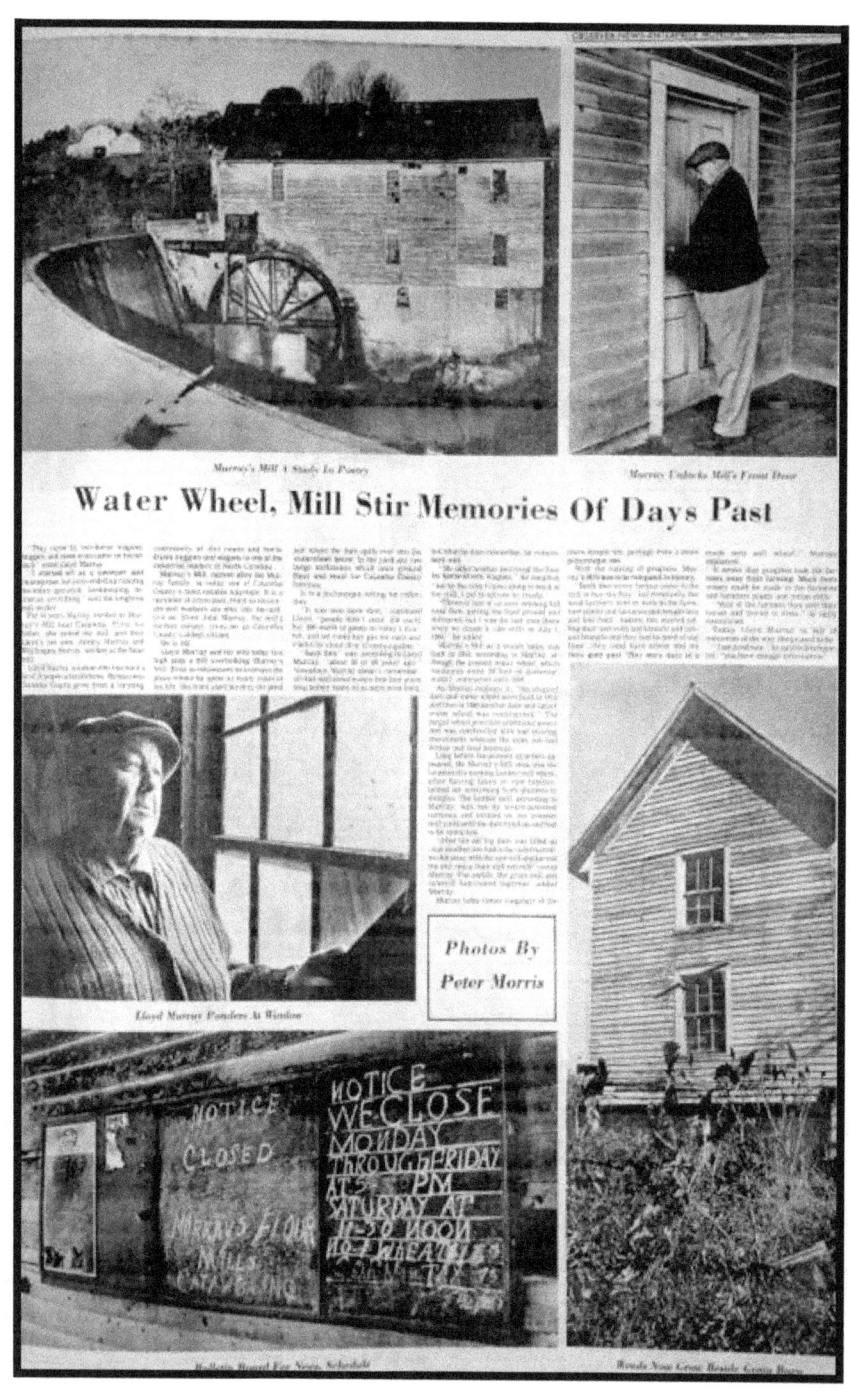

An old man and his waterwheel mill; I shot many photos.

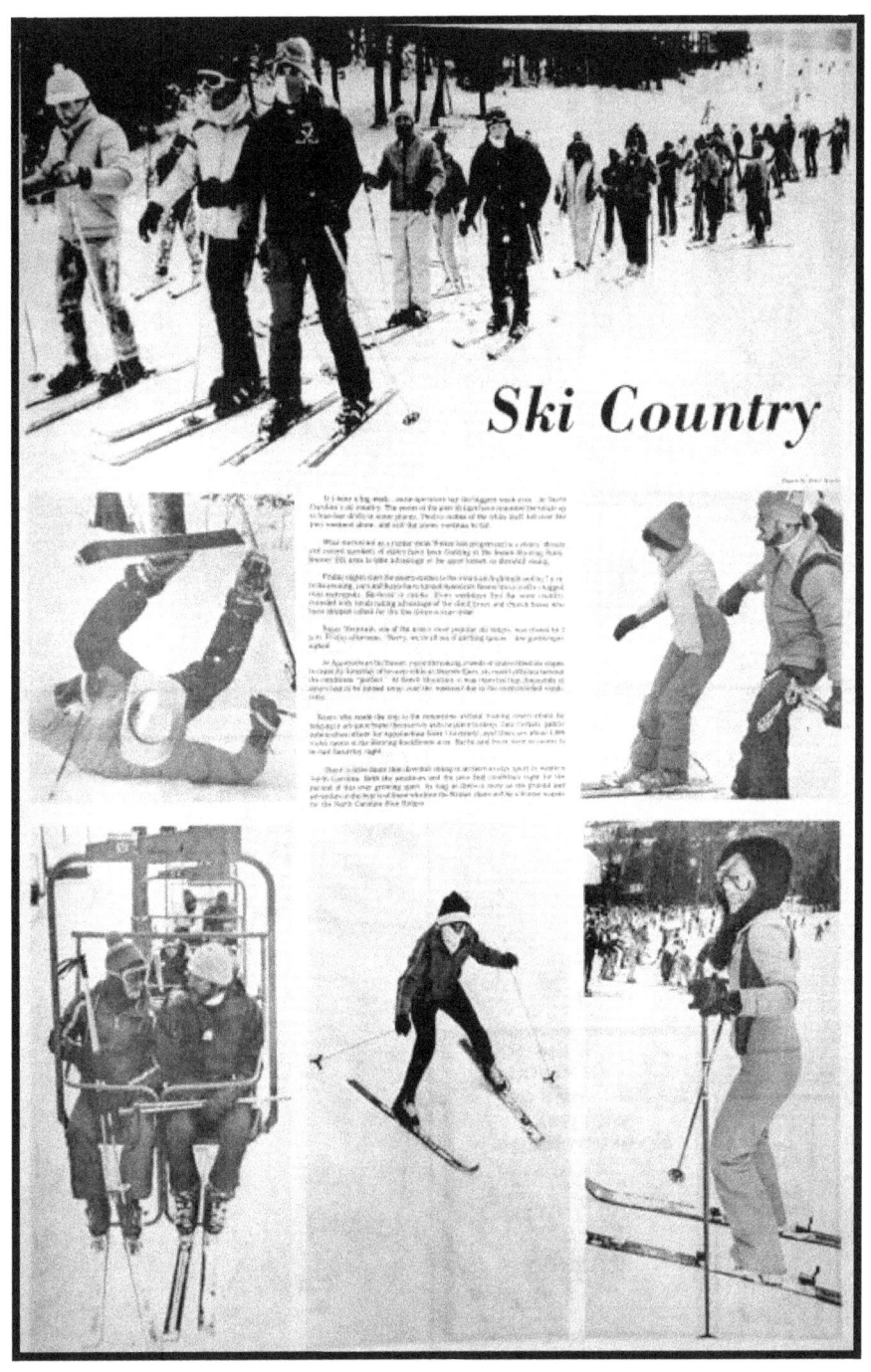

When the ski slopes open, the cameras come out.

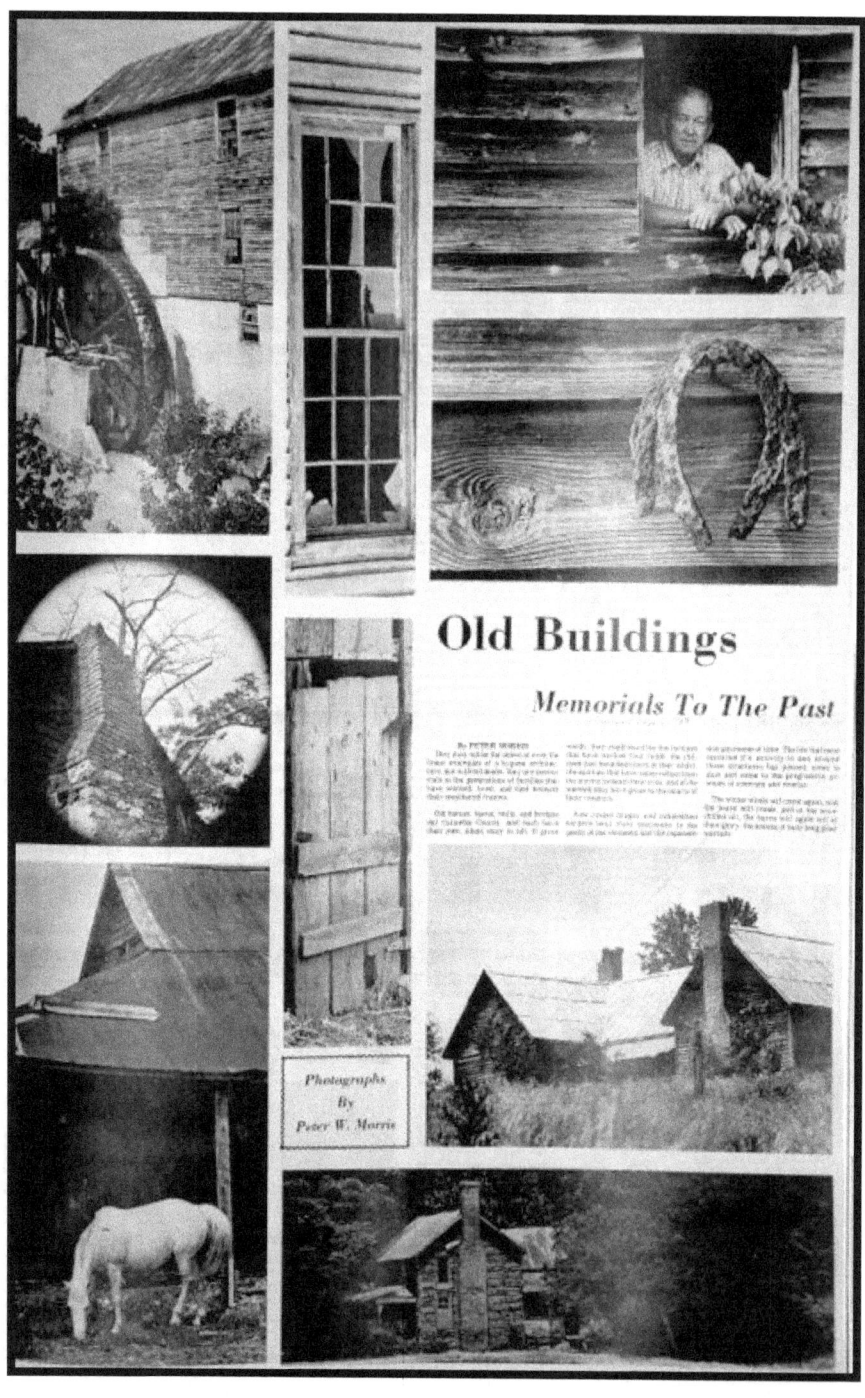

Old farms have a beauty all their own. The more creative the framing the better.

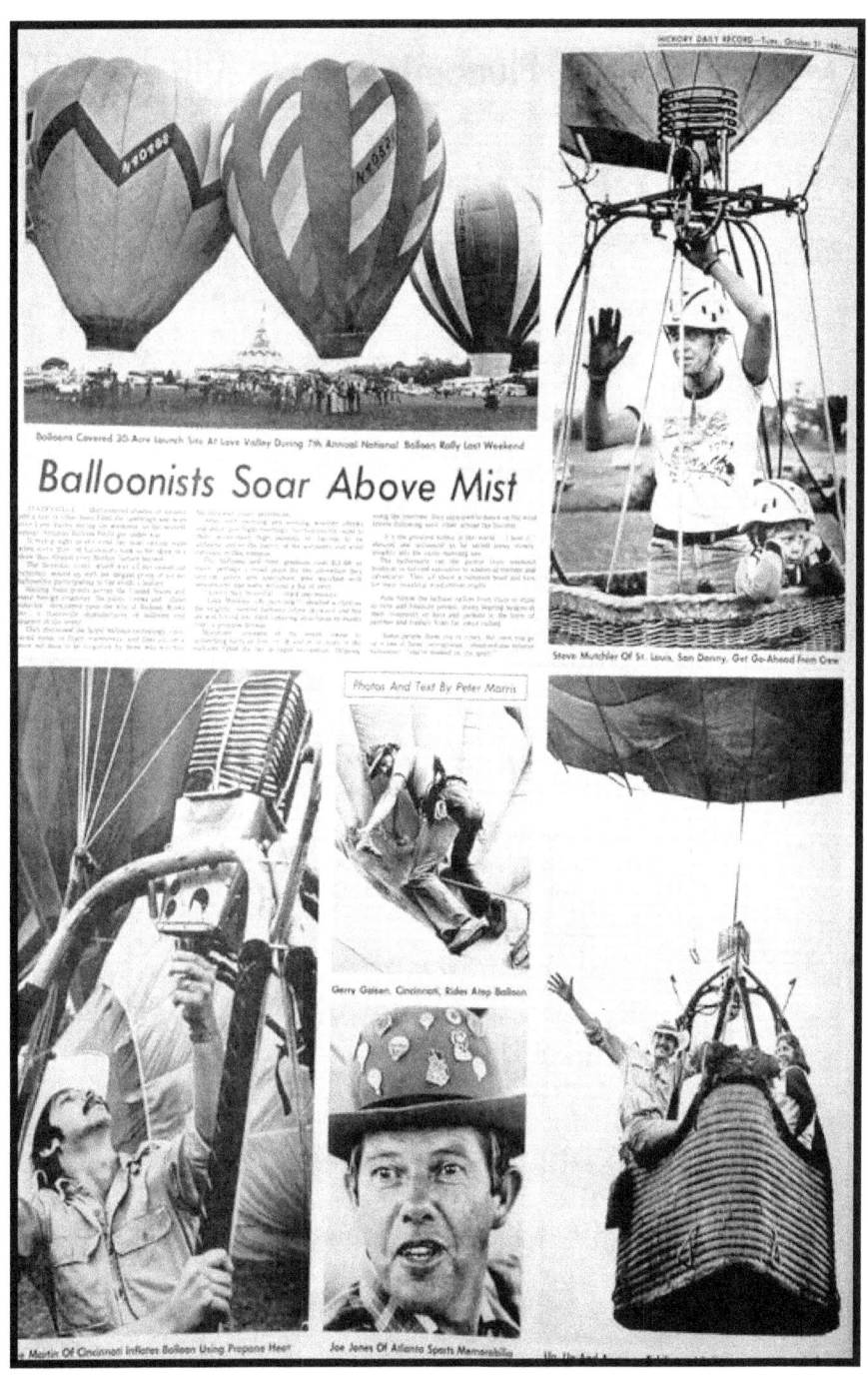

It's hard to go wrong when covering a hot air balloon rally. This was produced before the newspaper started running color.

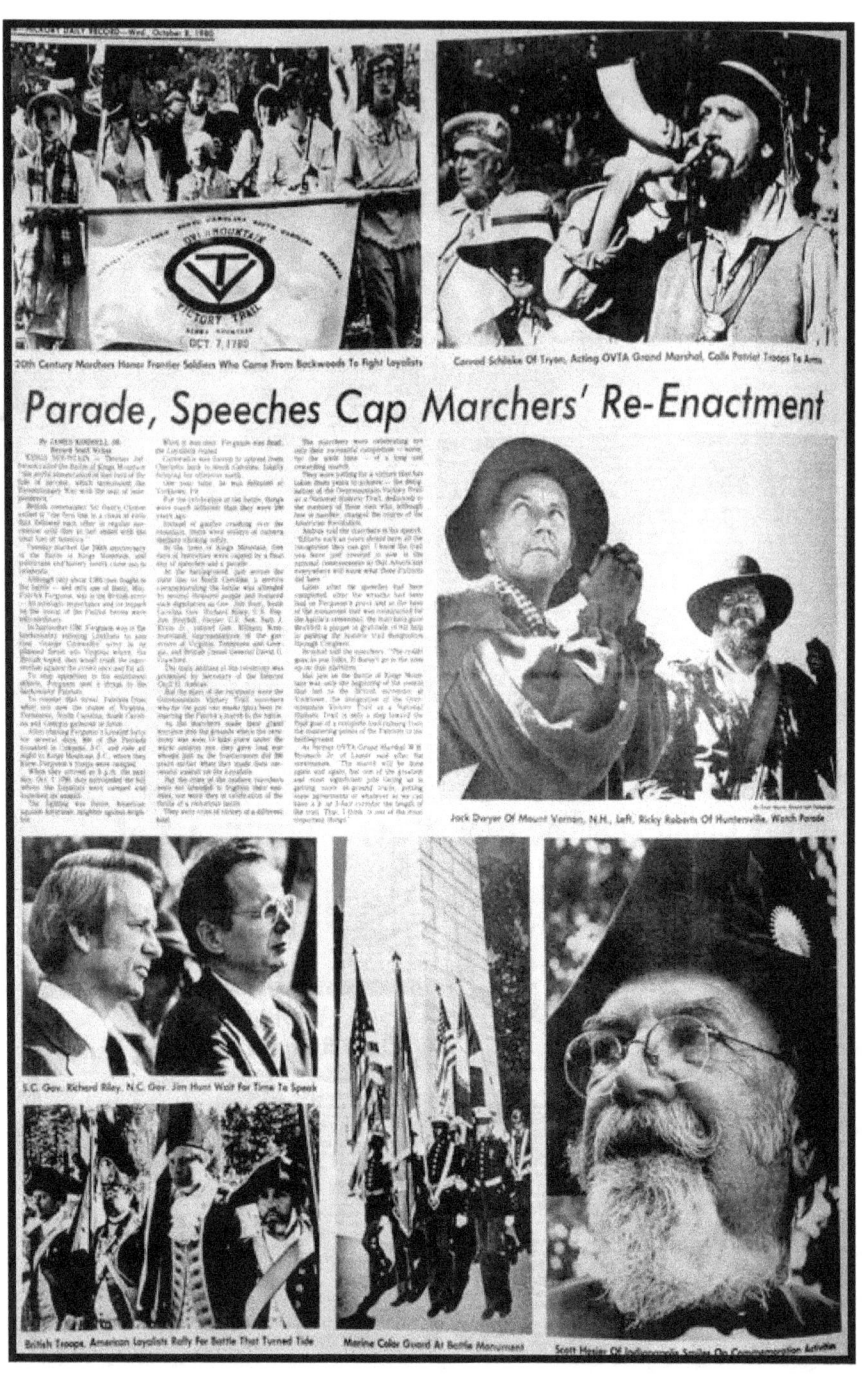

Reenactments provide a wonderful opportunity to hone photographic creativity.

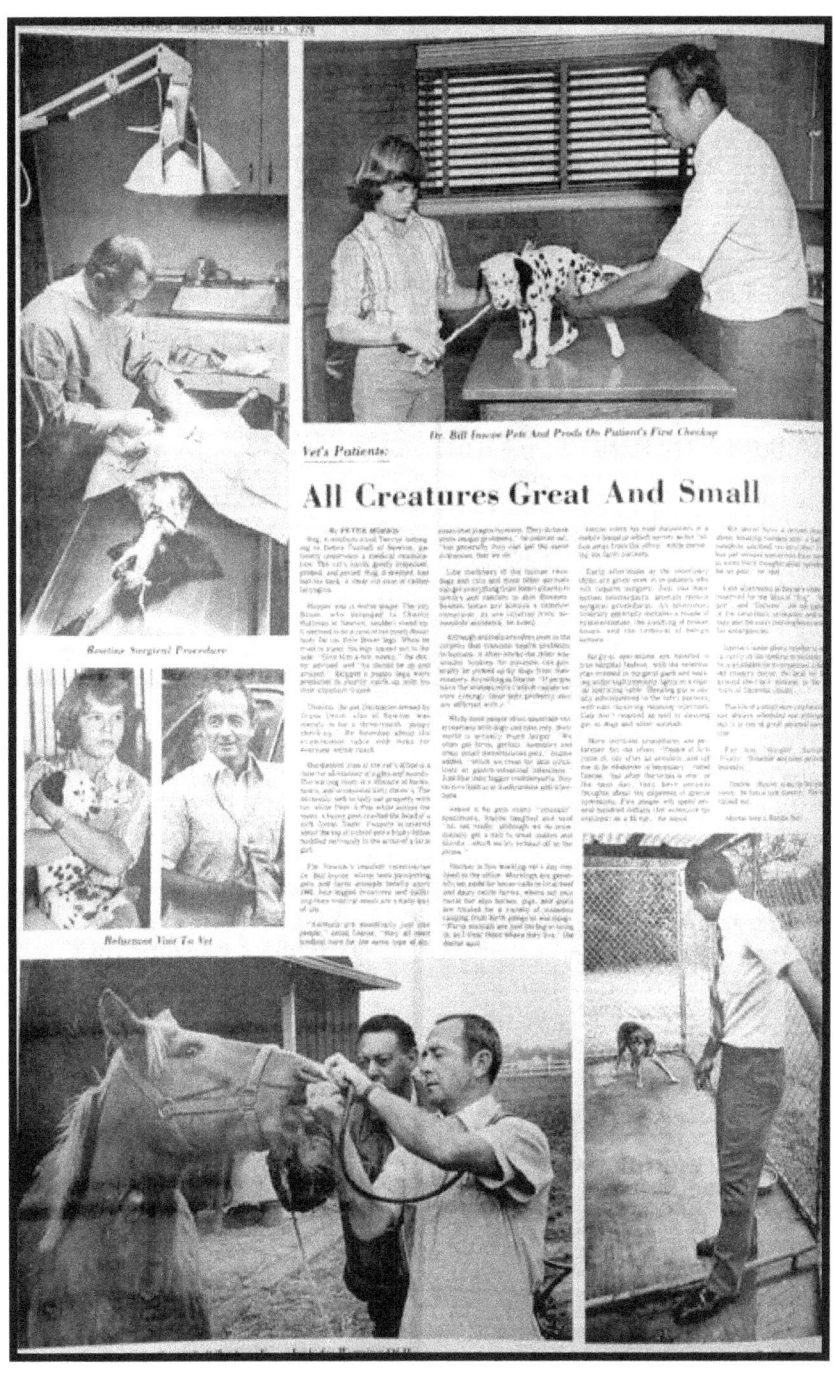

Following a veternarian on his rural rounds is a delight with a camera.

A Final Word

In addition to the ***Mountain Times***, photographic picture pages in this book also appeared in such other publications as the ***Hickory Daily Record*** (Hickory, North Carolina), the ***Observer News Enterprise*** (Newton, North Carolina) and the ***Charlottesville Daily Progress*** in Virginia..

Other photographic books by Peter W. Morris, also available on Amazon.com in both the United States and Europe include:

- ***On Assignment***: Adventures at the Ends of the Earth
- ***Shooter***: Days and Nights of a Photojournalist
- ***Ocracoke***: Blackbeard's Island
- ***Rembrances and Realizations***
- ***Travel Tales*** (Out of print.)

www.ingramcontent.com/pod-product-compliance
Lightning Source LLC
Chambersburg PA
CBHW080716190526
45169CB00006B/2404